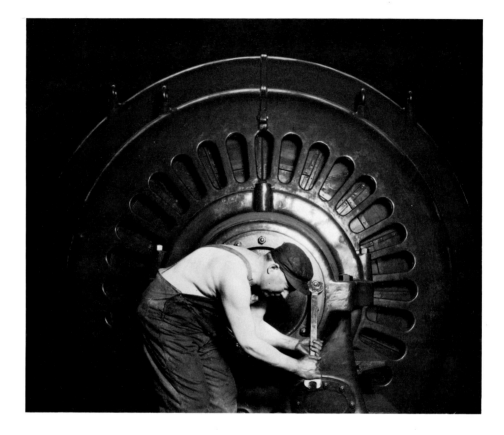

# MEN AT WORK

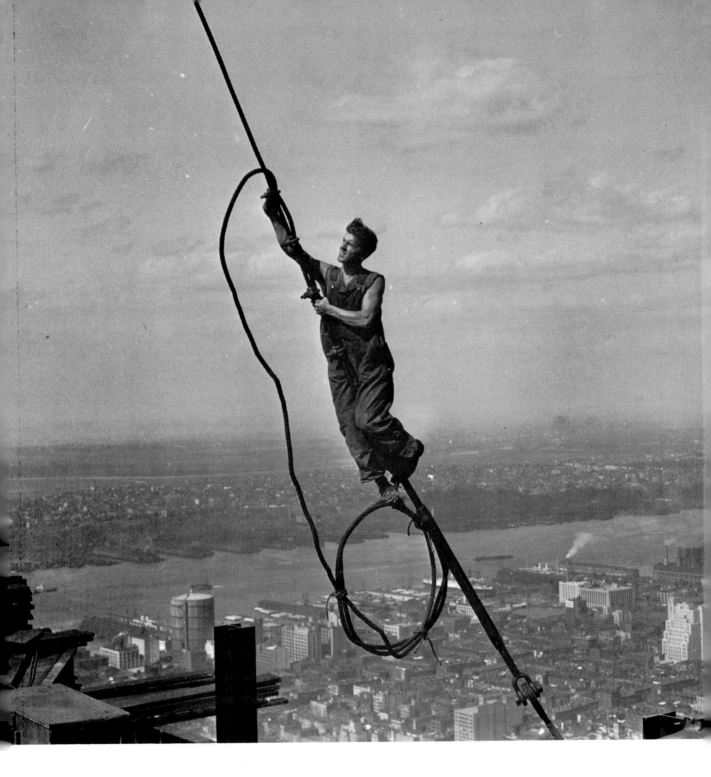

# THE SKY BOY

One of the first men to swing out a quarter of a mile above
New York City, helping to build a skyscraper.

# MEN AT WORK

## PHOTOGRAPHIC STUDIES OF MODERN MEN AND MACHINES

### By Lewis W. Hine

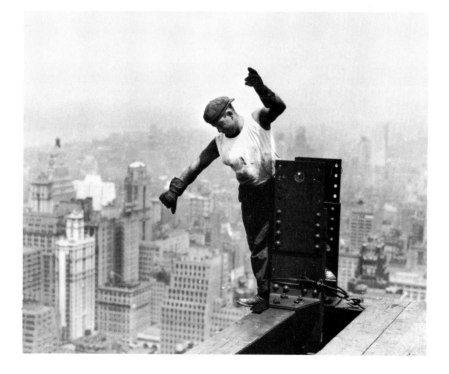

DOVER PUBLICATIONS, INC., NEW YORK

and

International Museum of Photography at
George Eastman House, Rochester

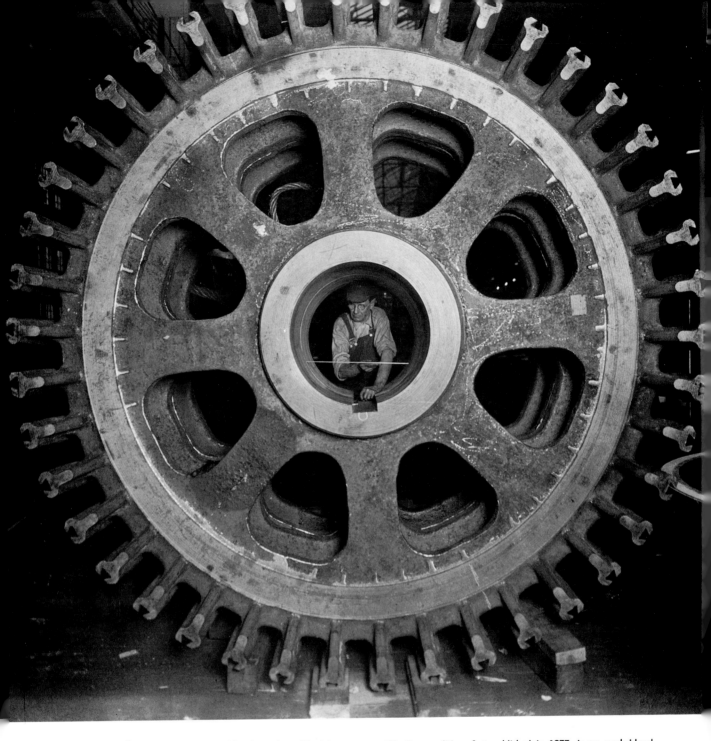

Published in Canada by General Publishing Company, Ltd., 30 Lesmill Road, Don Mills, Toronto, Ontario. Published in the United Kingdom by Constable and Company, Ltd., 10 Orange Street, London WC2H 7EG.

This Dover edition, first published in 1977, is an unabridged republication of the work originally published by The Macmillan Company, N.Y., in 1932. The photographs have been newly reproduced from original prints in the collection of the International Museum of Photography at George Eastman House, Rochester. The same collection has made available the 18 Hine prints that appear in the Supplement to the present edition. A new Introduction has been written specially by Jonathan L. Doherty.

International Standard Book Number: 0-486-23475-4
Library of Congress Catalog Card Number: 76-50337

Manufactured in the United States of America
Dover Publications, Inc.
180 Varick Street
New York, N.Y. 10014

# TO MY FRIEND
# FRANK A. MANNY

"Not in clanging fights and desperate marches only is heroism to be looked for, but on every bridge and building that is going up today, on freight trains, on vessels and lumber-rafts, in mines, among firemen and policemen, the demand for courage is incessant and the supply never fails. These are our soldiers, our sustainers, the very parents of our life."—William James, in "The Moral Equivalent of War."

Acknowledgment is due various companies through whose coöperation this series of studies has been possible; Empire State, Inc., General Electric Company, Pennsylvania Railroad, Pennsylvania Rubber Company, American Airplane Corporation, Sperry Gyroscope, Ingersoll-Rand Company, The Survey Graphic.

# INTRODUCTION TO THE DOVER EDITION

Lewis W. Hine (1874–1940) was a photographer who began taking pictures in 1903 and never stopped photographing until his death in 1940. During this span of almost forty years, Hine proceeded to document the parts of American society that he felt needed to be shown to the public. In an often quoted statement, he said, "There are two things I wanted to do. I wanted to show the things that had to be corrected. I wanted to show the things that had to be appreciated." Hine documented the immigrants arriving at Ellis Island, the life of the steel workers in Pittsburgh, child labor in the United States, the sweatshops and slums of New York City, World War I (for the Red Cross), the Tennessee Valley Administration (TVA) projects and the National Research Project of the Works Progress Administration (WPA). In addition to all this, there were his monumental pictures of *Men at Work* and the construction of the Empire State Building.

Hine is most widely known for his photographs of Ellis Island and his work with the National Child Labor Committee. They are, indeed, some of his finest pictures and along with the tenement and Red Cross series, characterize the early part of his photographic life. Up to his return from Europe in 1919, Hine was essentially showing the negative side of life in his pictures—the ten-year-old child working a twelve-hour shift in a textile mill, the filthy slums with children searching through garbage, and the atrocities of the Great War. Many of these photographs were used to activate the emotion that only photographs could bring to the reform movements then taking place. In effect, Hine was a detective searching for wrongdoing with his camera and, when he found it, using his pictures to help indict the criminals. When he returned from Europe, however, Hine realized that so far he had been criticizing with his photographs, and decided that it was just as important to give praise to things that were worthy of it. From then on, most of Hine's work was with the positive aspects of life. This is when he began his photographic documentary of *Men at Work*. He went out and photographed workers at the docks, in glass factories, powerhouses, machine shops, mills, railroad yards and everywhere else he could find them. This series of pictures climaxed with the extraordinary photographs that Hine took of the construction of the Empire State Building from the bedrock to the top of the mooring mast. In 1932, Hine chose a group of images from the thousands that he had taken in this series and published them as *Men at Work*, of which this book is a reprint.

Hine seems to have had many reasons for publishing *Men at Work,* besides showing the positive side of life. The book as a whole corresponds to the idea of the Protestant Work Ethic. Hine looked at workingmen with his camera and found a strength in them and a pride in their work that was common to all. This is what he wanted to show the American public through *Men at Work.* There is more, however, and it is shown through Hine's preface to the original edition and through the photographs themselves. Hine showed the relationship between the men and their machines—that it is the men who are controlling the machines to create a better life for themselves. They are not dwarfed by the construction of a giant turbine or a railroad car or a great skyscraper, for they are the ones who have built them. Lewis Hine was an extremely sensitive photographer who had deep respect for the good things in life that he photographed. In fact, in *Men at Work* Hine elevated the American worker to the status of a hero.

To illustrate further Hine's documentation of the construction of the Empire State Building, a supplement of 18 photographs has been added at the end of this volume.

Jonathan L. Doherty

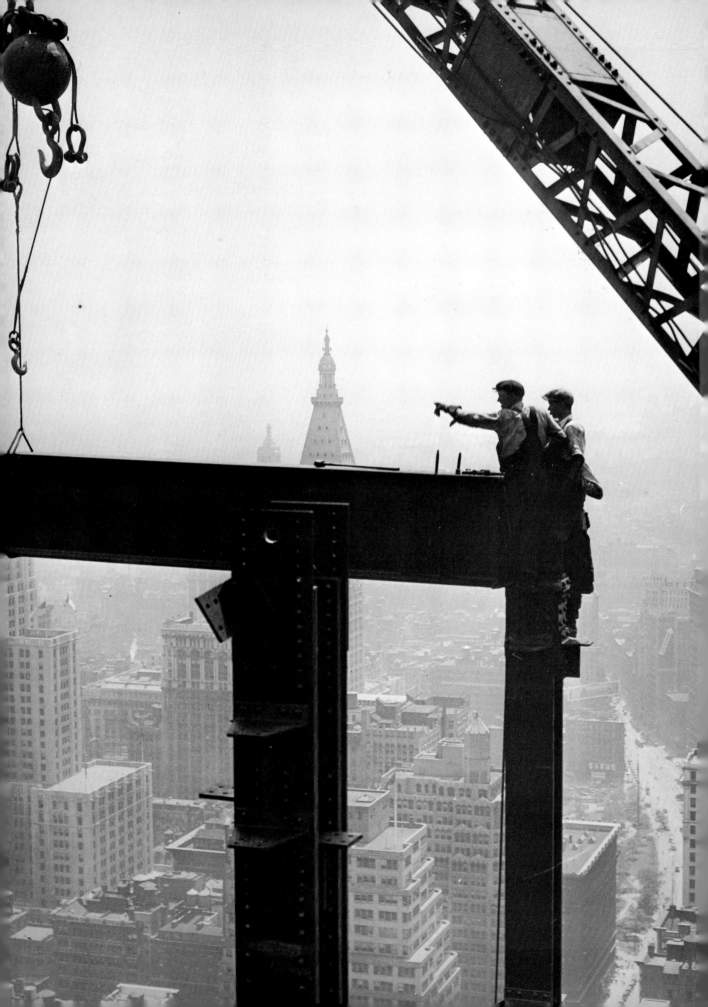

# THE SPIRIT OF INDUSTRY

THIS is a book of Men at Work; men of courage, skill, daring and imagination. Cities do not build themselves, machines cannot make machines, unless back of them all are the brains and toil of men. We call this the Machine Age. But the more machines we use the more do we need real men to make and direct them.

● I have toiled in many industries and associated with thousands of workers. I have brought some of them here to meet you. Some of them are heroes; all of them persons it is a privilege to know. I will take you into the heart of modern industry where machines and skyscrapers are being made, where the character of the men is being put into the motors, the airplanes, the dynamos upon which the life and happiness of millions of us depend.

● Then the more you see of modern machines, the more may you, too, respect the men who make them and manipulate them.

—L.W.H.

Hastings-On-Hudson
May, 1932

# FOUNDATION

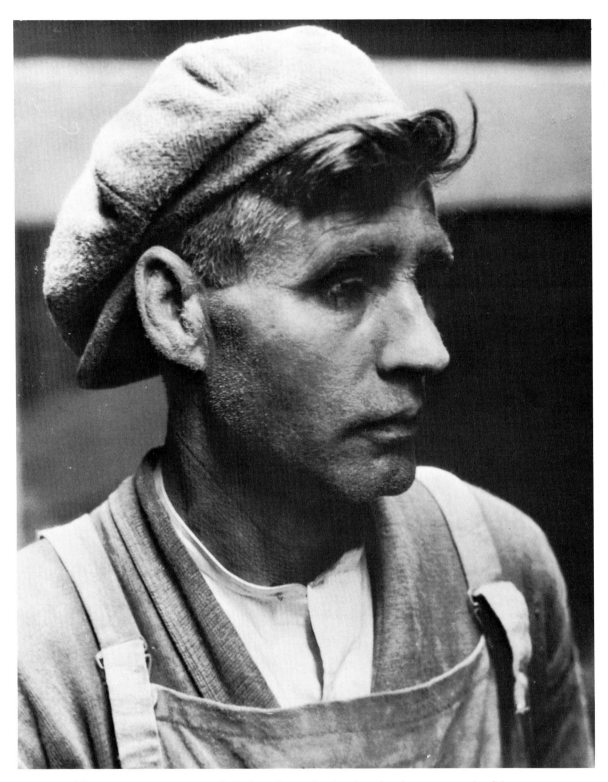

Their noisy pneumatic drills break up the bed rock where a new building is to stand. They work in a haze of rock dust which they know will shorten their lives. The man above received an award for craftsmanship.

# MEN

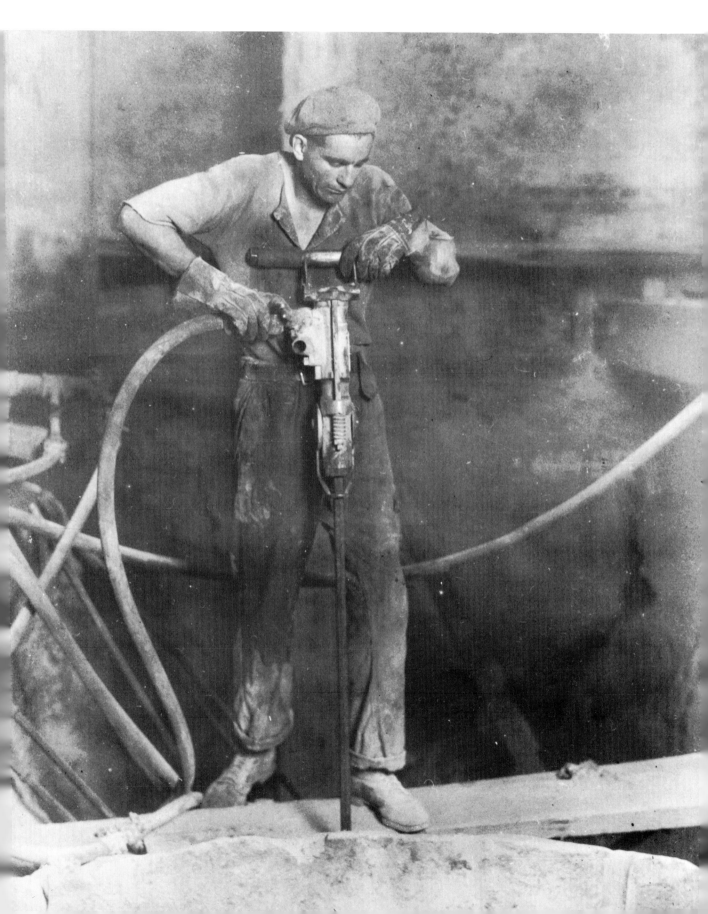

# DERRICK MEN

The man below is turning and directing a great derrick; the connecters opposite are receiving a beam to lay it in place.

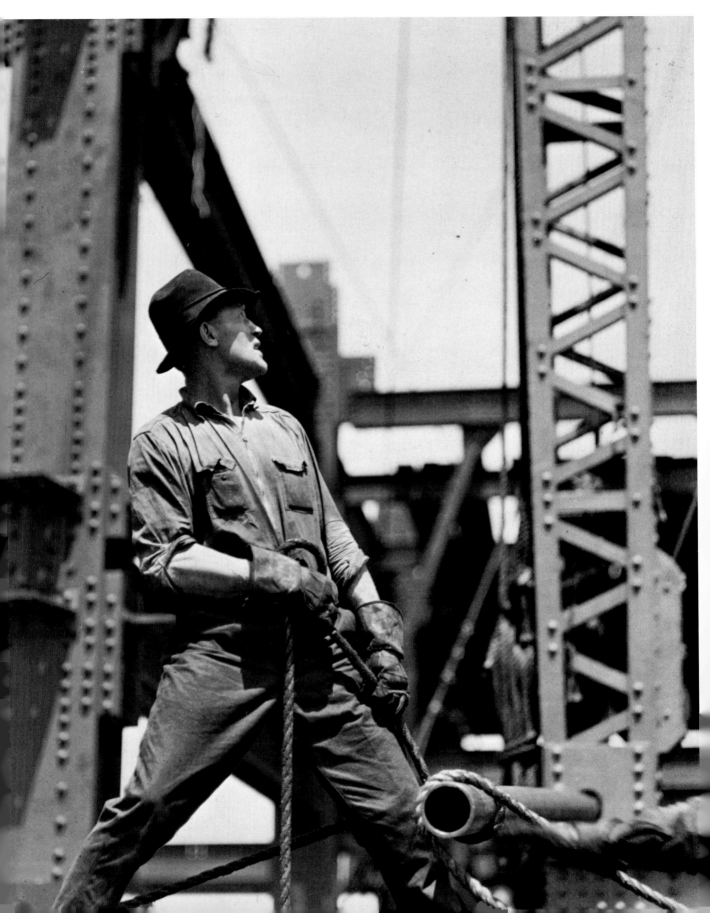

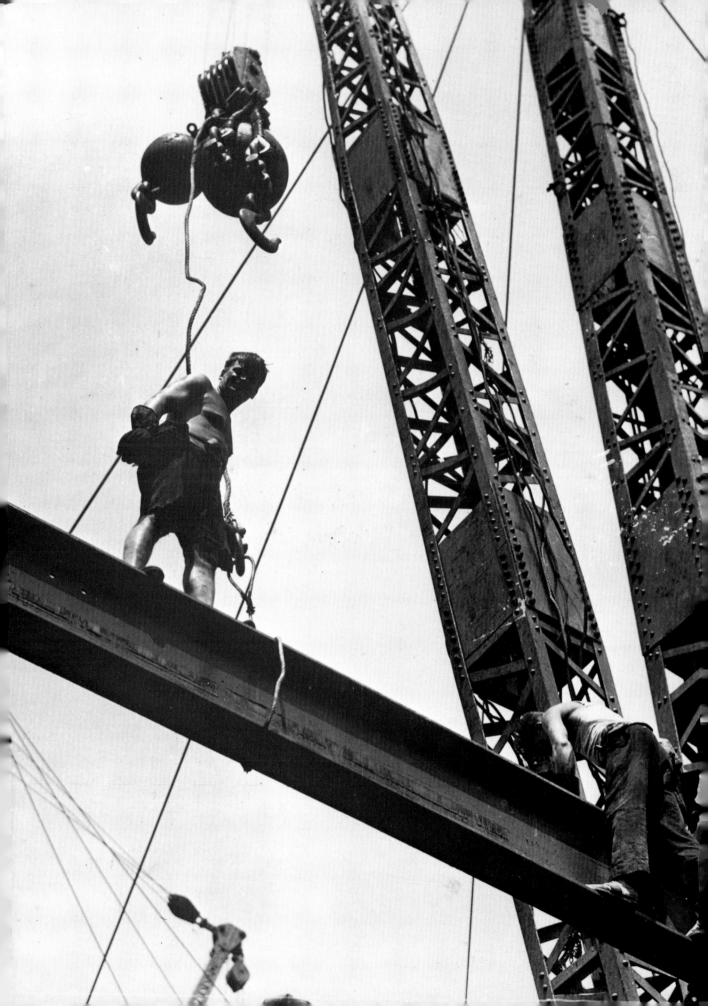

The hoist engineer controls the cable that lifts the load. He takes his signal on the gong from the bellman (right) located near the derrick, who decides when it must start and stop, and rings the gong for the engineer below.

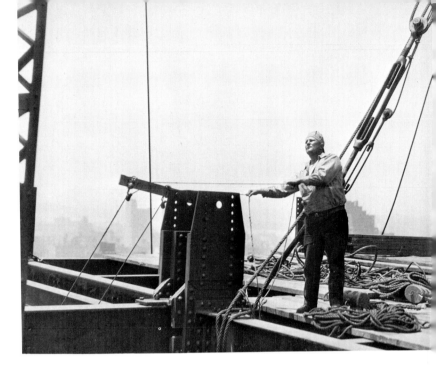

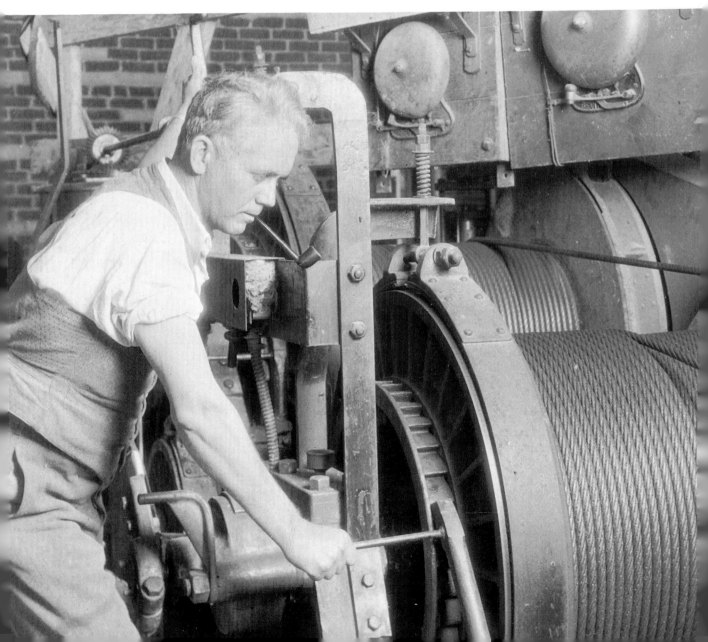

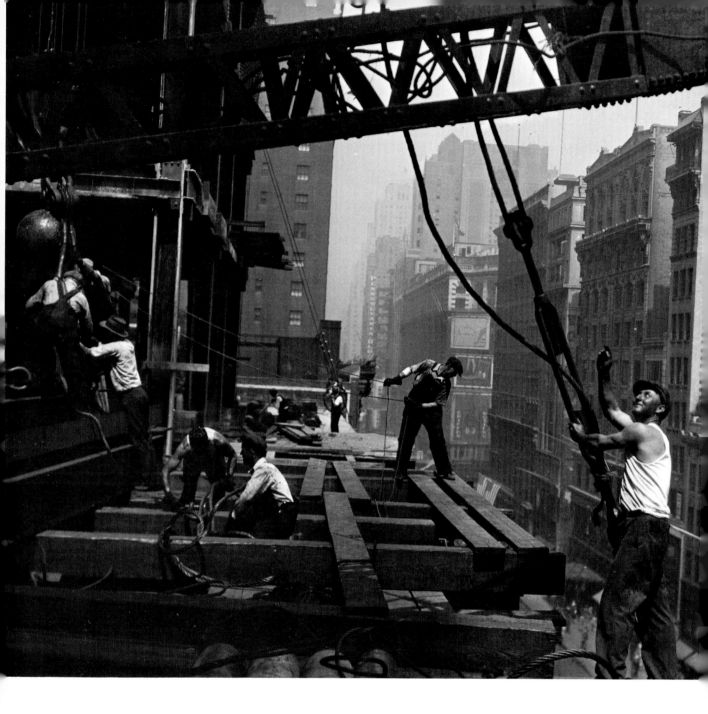

The hoisting gang attach the great cables to the beams,
steer and shift them into place, and wave their signals
to the bellman. Careful teamwork is necessary; every
man is alert at every minute to do his part.

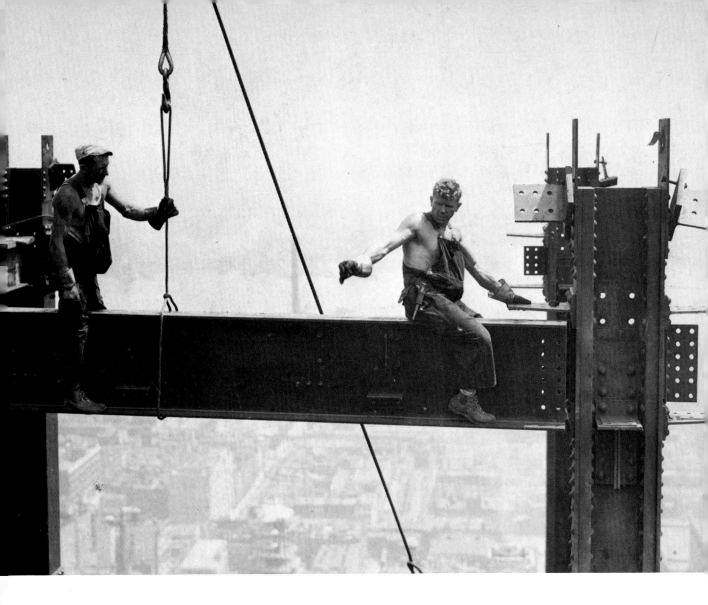

As the building pushes skyward the connecters stay aloft
and bolt the beams after they have swung into place.
Two of them (opposite) are going up to the next height,
like spiders spinning a fabric of steel against the sky.

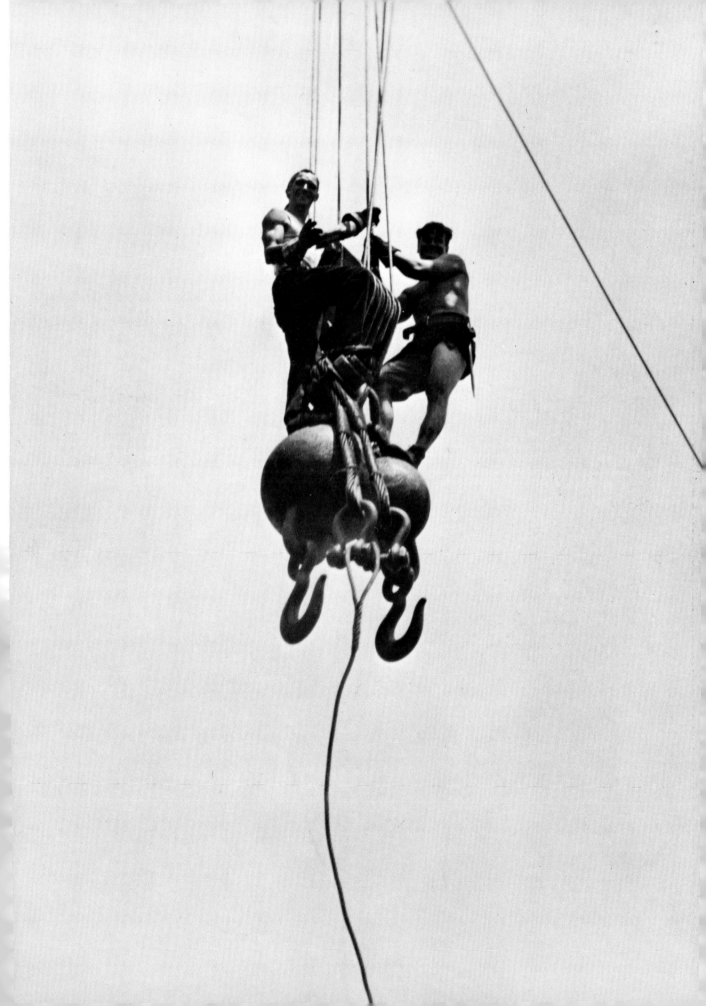

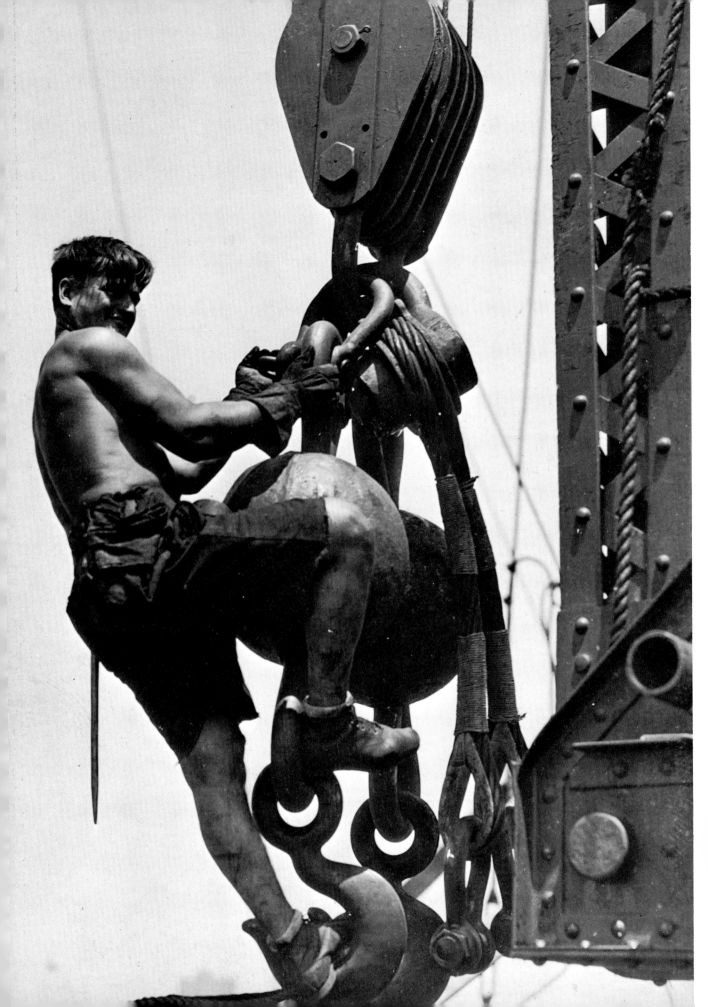

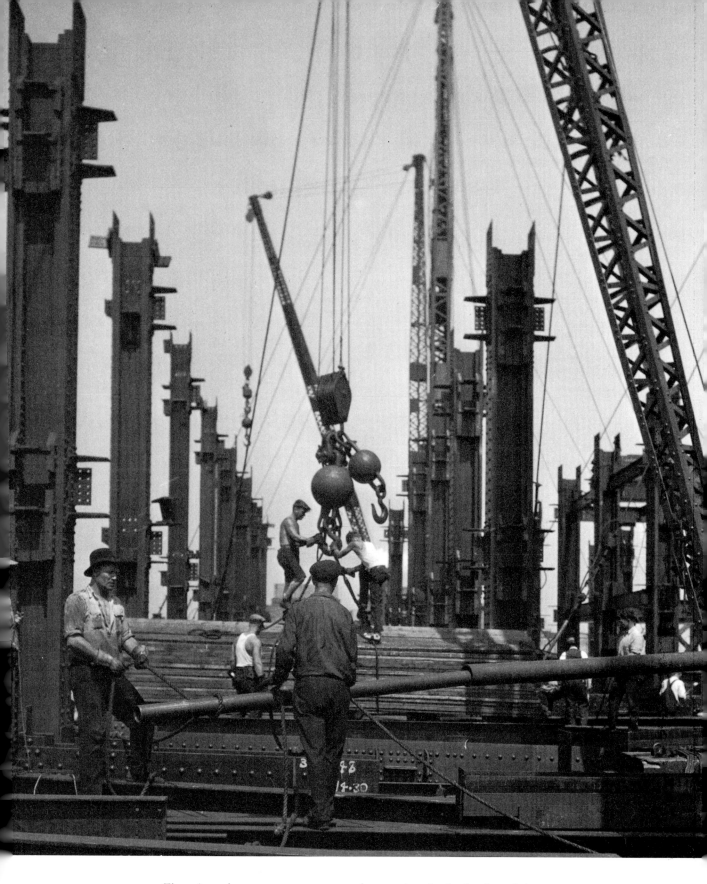

This derrick gang is moving a heavy load of planks while men in the foreground extend the bull-stick of the derrick for greater leverage. Opposite, another connecter goes aloft.

# CHECKING UP

The work is checked continually to make the building "true." A group of engineers, with their surveyors' instruments, check the vertical lines before it is too late to correct them. As soon as each column has been placed a plumber-up drops his bob and the huge steel column is straightened.

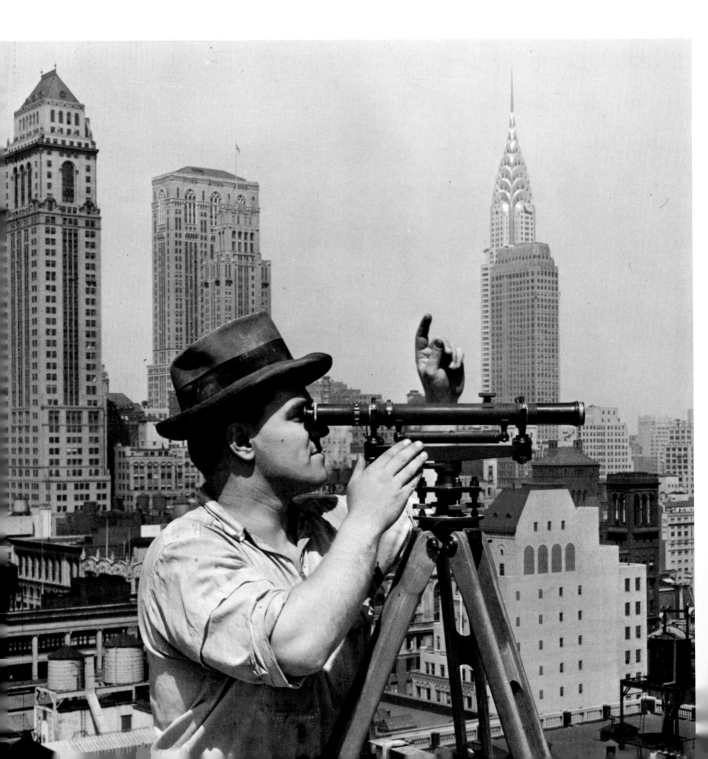

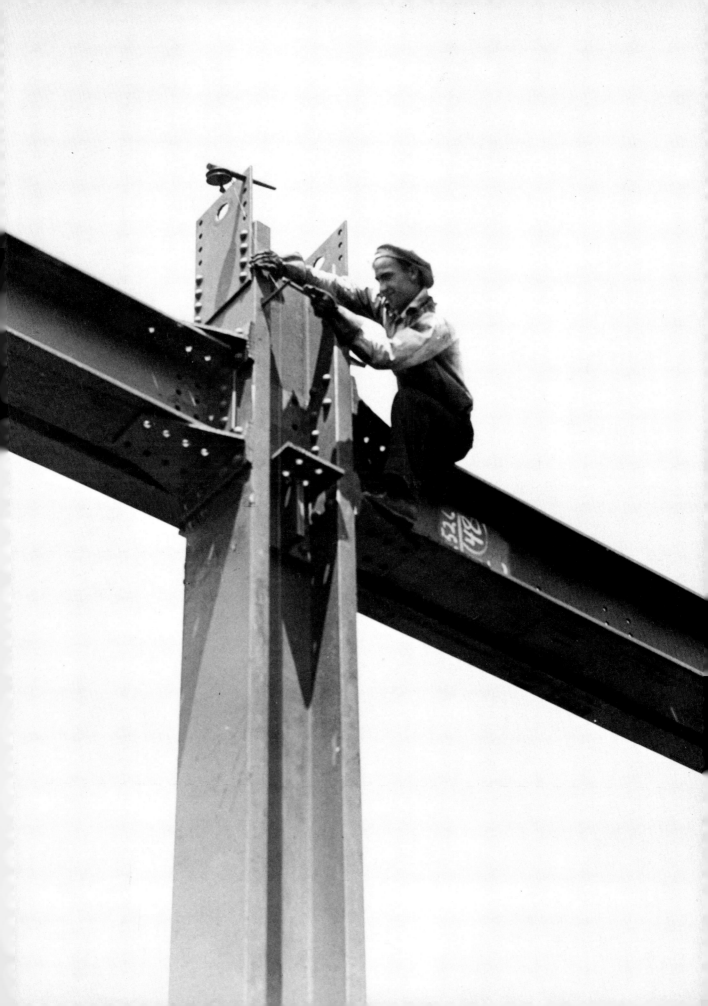

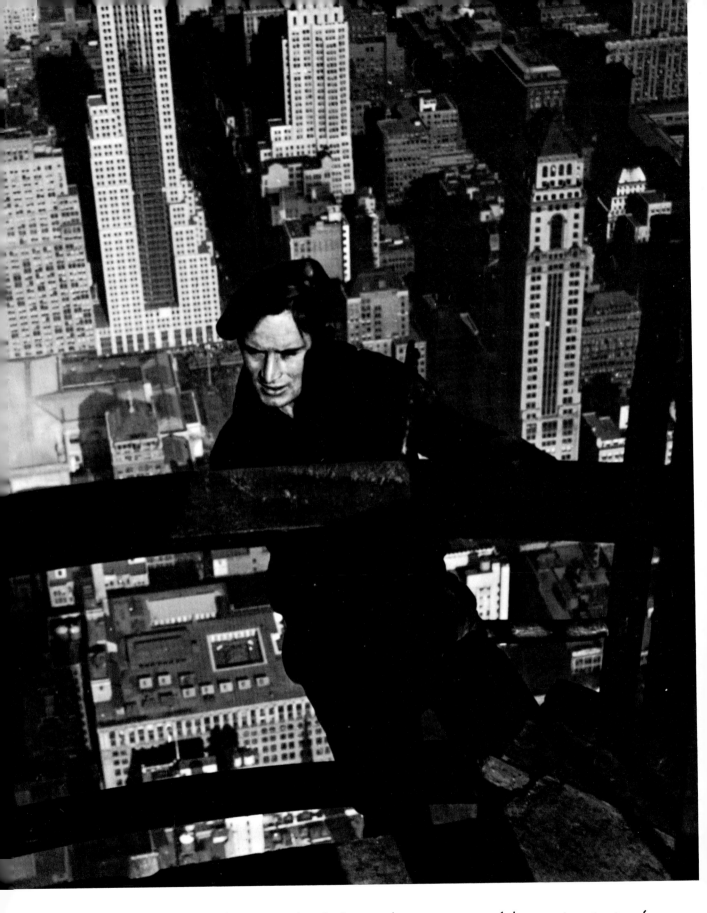

Another check-up is the safety man, who climbs searching every part of the growing structure for a loose board, a neglected wire or tool. He safeguards the workers and the people below in the street. The hoister (opposite) watches with special care as he guides a great load of steel beams.

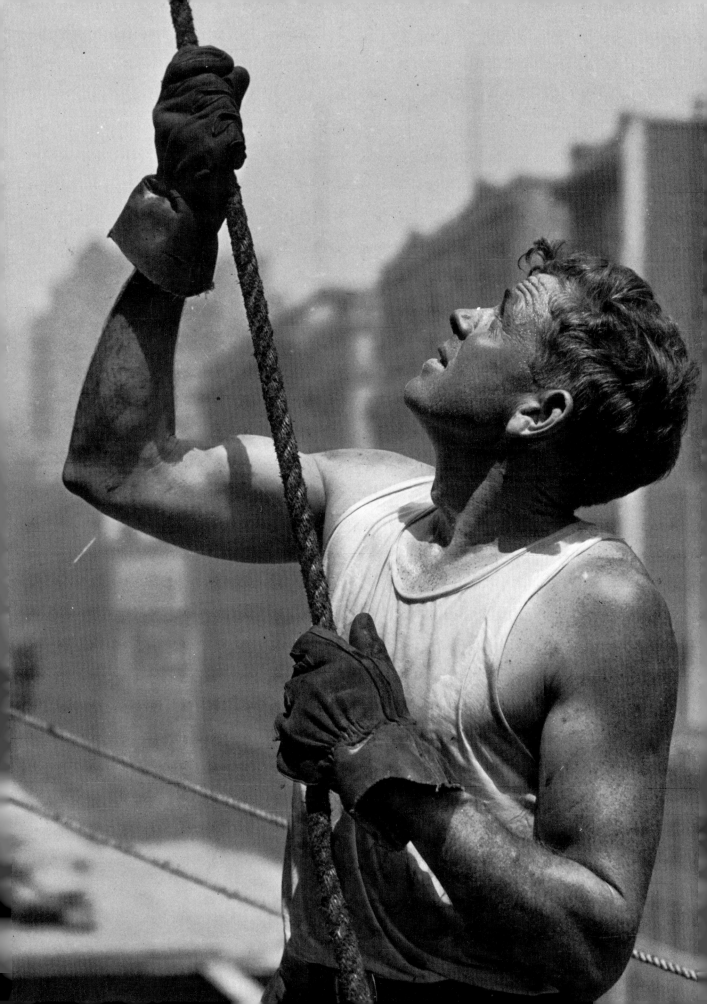

# RIVETING GANG

The riveter drives the bolt home with his pneumatic gun; the bucker-up holds the rivet in place; the catcher picks the red-hot bolt out of the air with his tin scoop, when it is thrown up from the floor below. Standing on a few planks, in high dangerous places, these men need skill, strength, and courage. "Safer up here than it is down below," is their idea of the job.

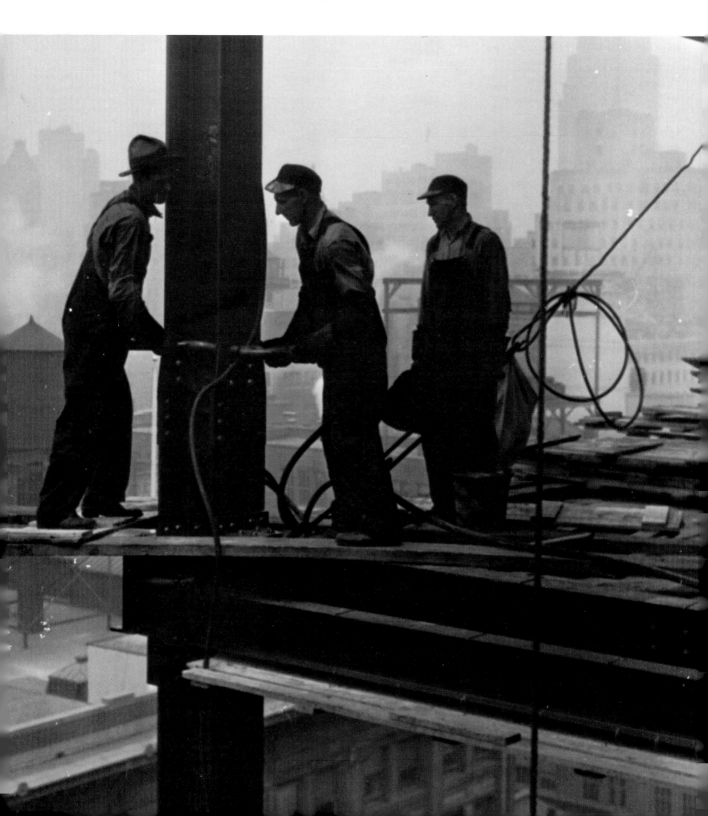

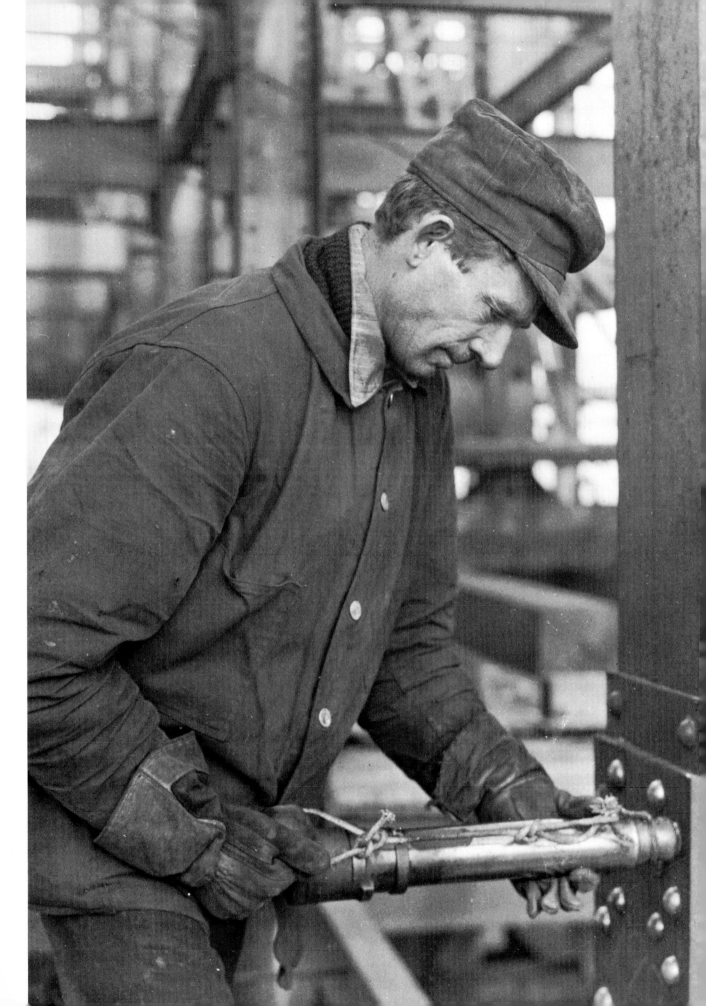

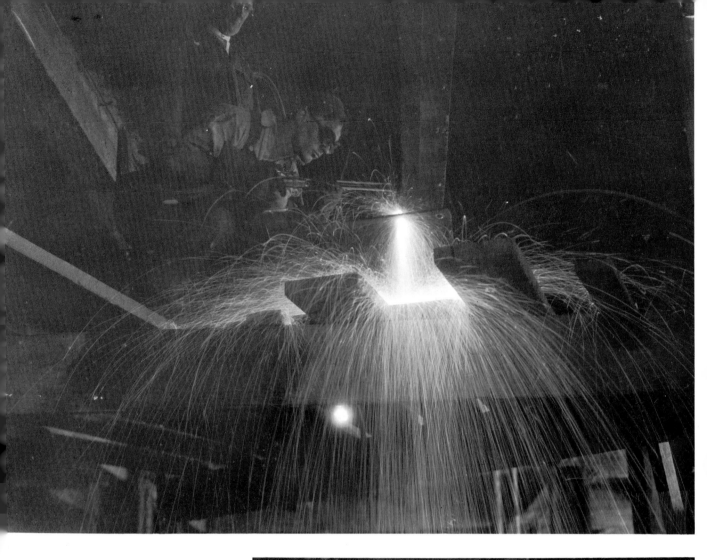

The burner, above, is cutting the beam with his acetylene torch. The heater, right, gets the bolts red hot and tosses them to the riveters. The welder, opposite, is working on a great steel pipe in its shaft. Industrial fireworks!

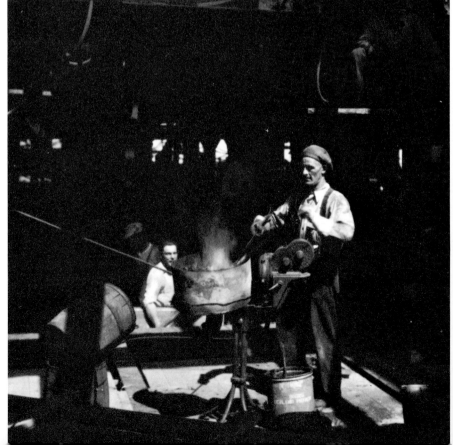

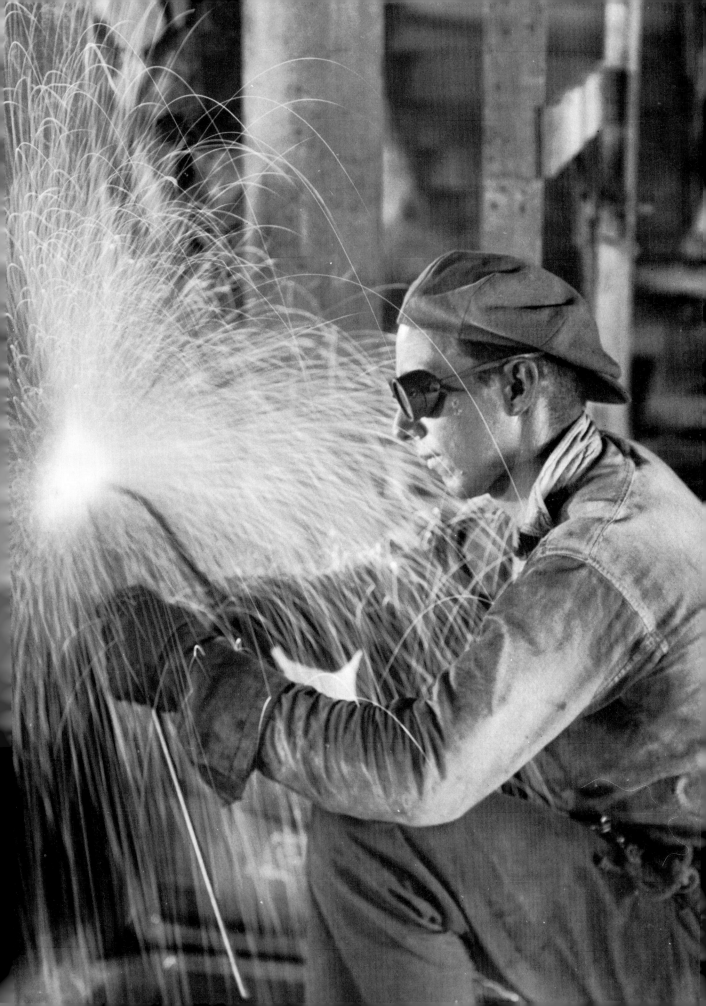

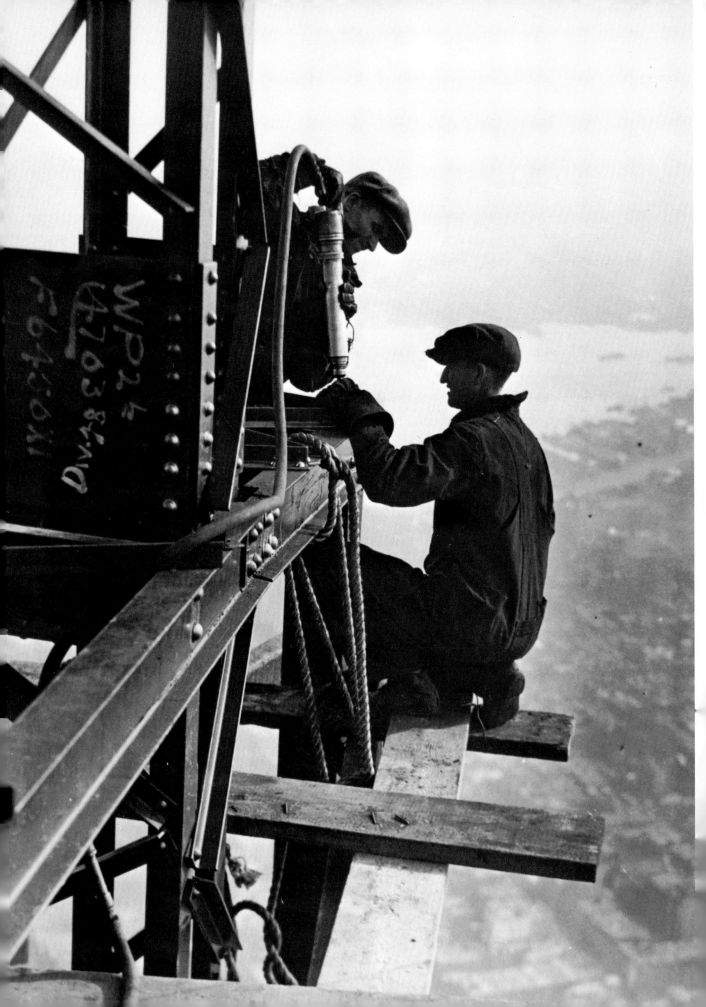

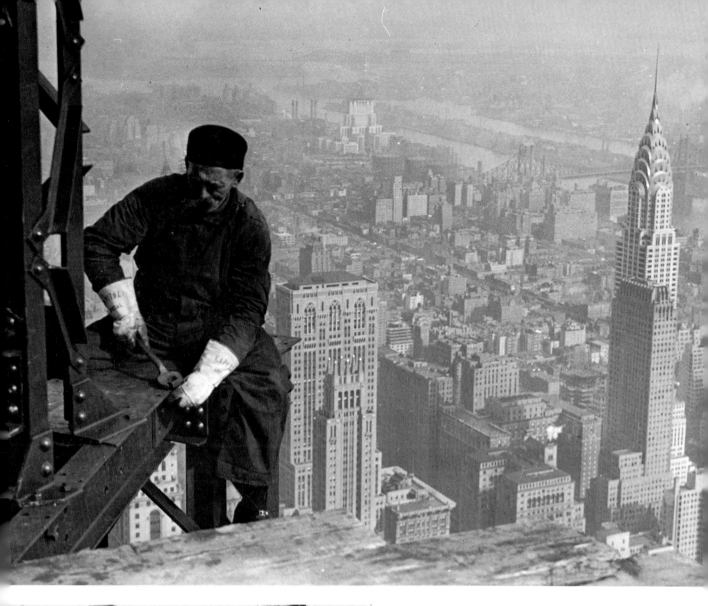

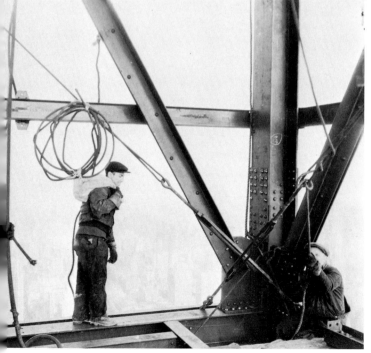

The bolt boy with a bag of bolts begins at eighteen. He hopes some day to be boss of the gang. He will have to take good care of himself, if he is to stay on the job as long as the old bolter above. Young and old, they all say it isn't really as dangerous as it looks.

(Opposite) Riveters working on a tower.

# FINISHING

A derrick man moves up to the next floor; soon the highest derrick will come down and the job will be over. The men opposite are working on the tip of the mooring mast on the Empire State Building. This is the highest point yet reached on a man-made structure, a quarter of a mile up in the clouds.

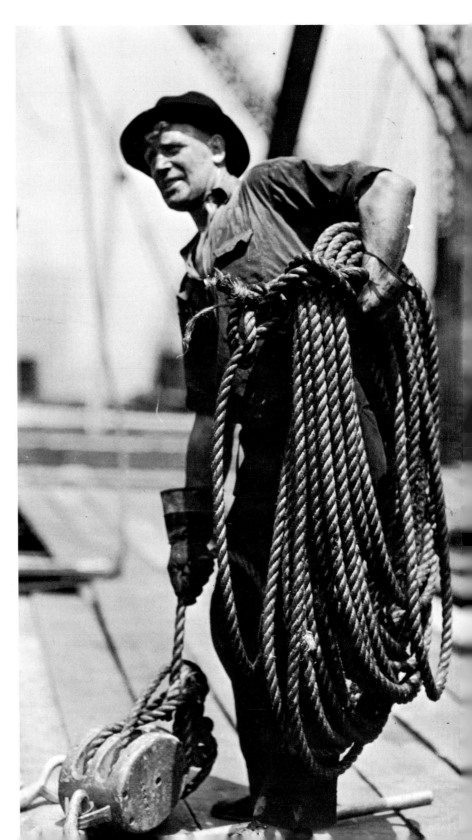

# UP THE JOB

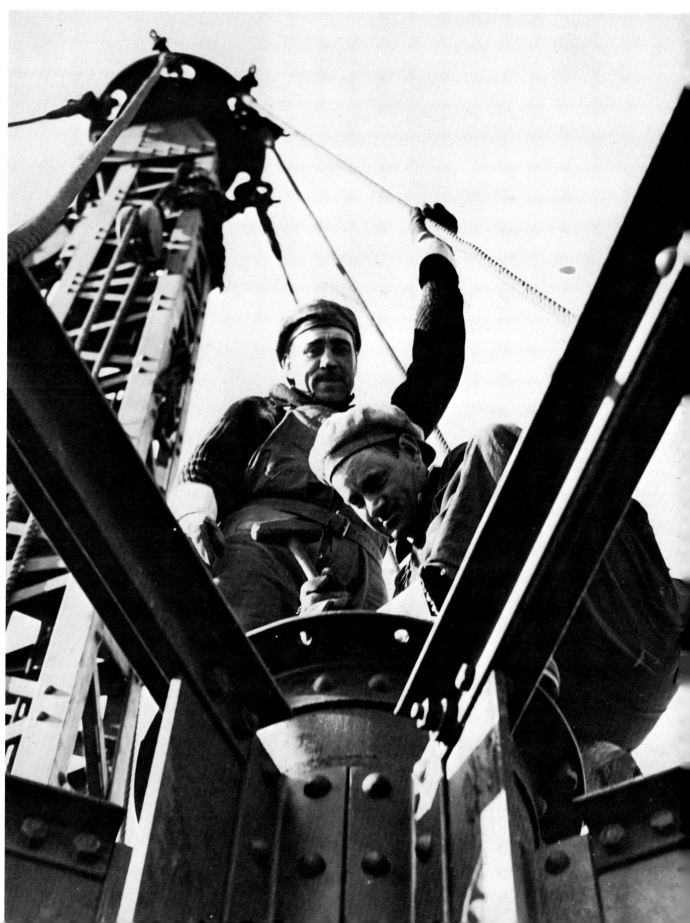

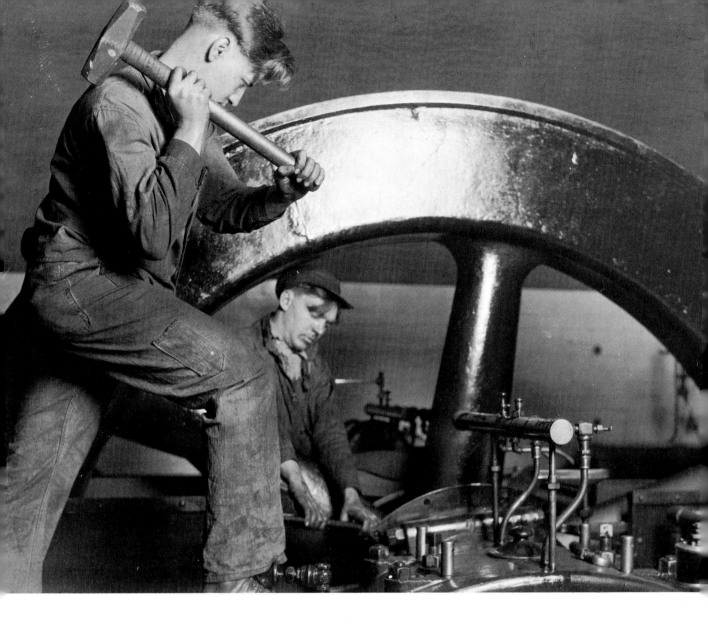

# RAILROAD MEN

This modern Thor swings his hammer in a power house that
sends driving force out along a great electric railroad line.

A railroad builder, at work on a car wheel in one of the great machine shops that turn out the engines of to-day.

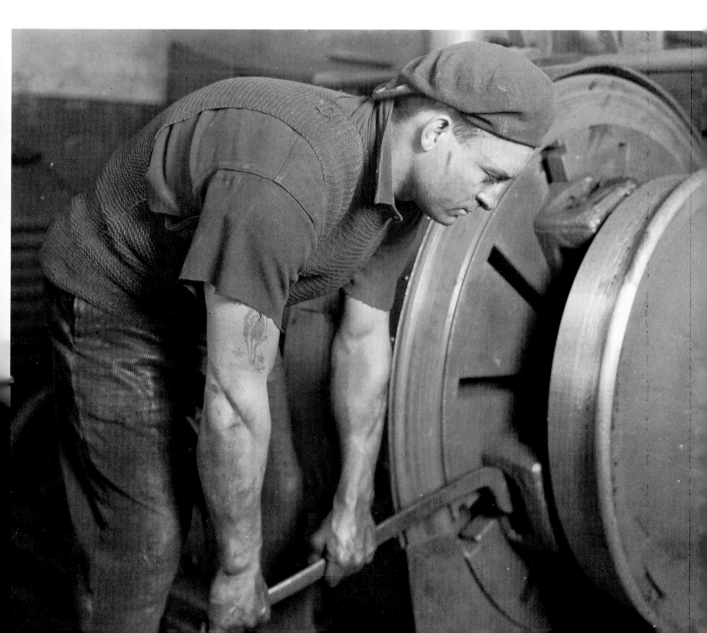

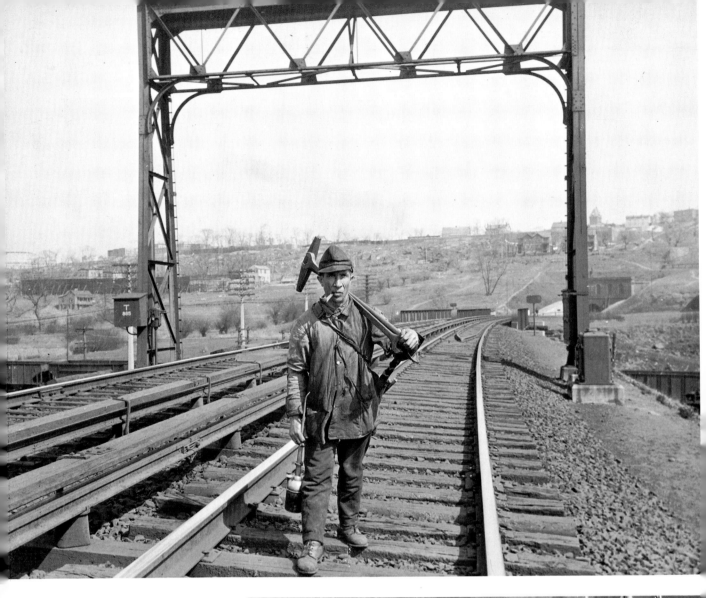

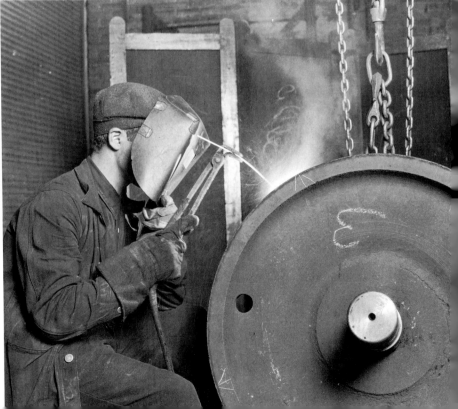

The track walker on his long patrol, looking for flaws in the miles of tracks; and another mechanic welding a car wheel which will soon roll over them.

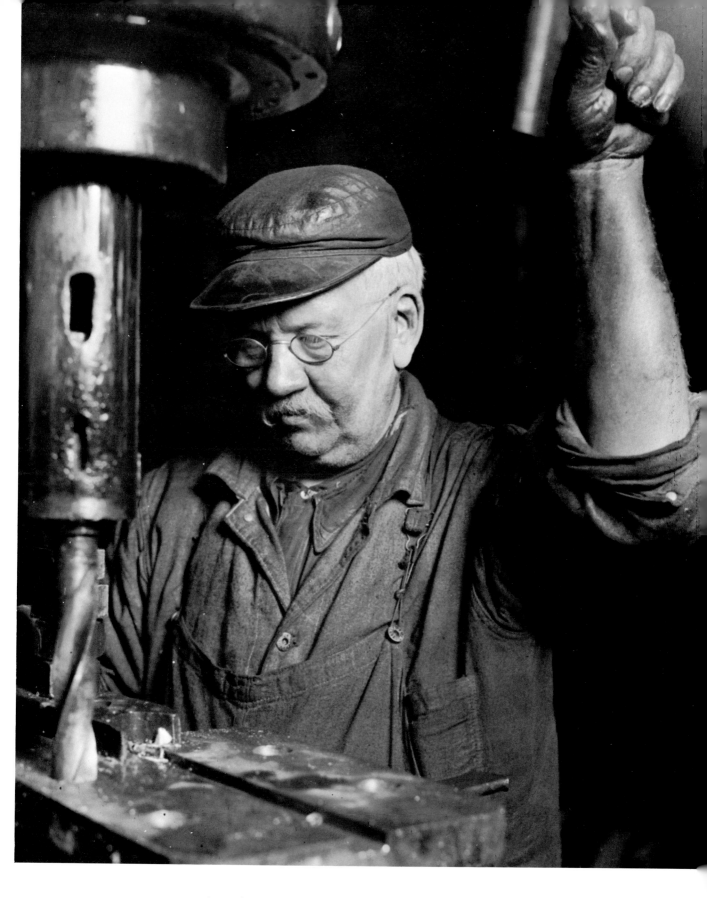

A worker of long experience carefully drills a huge
steel plate that will hold a Pullman car together.

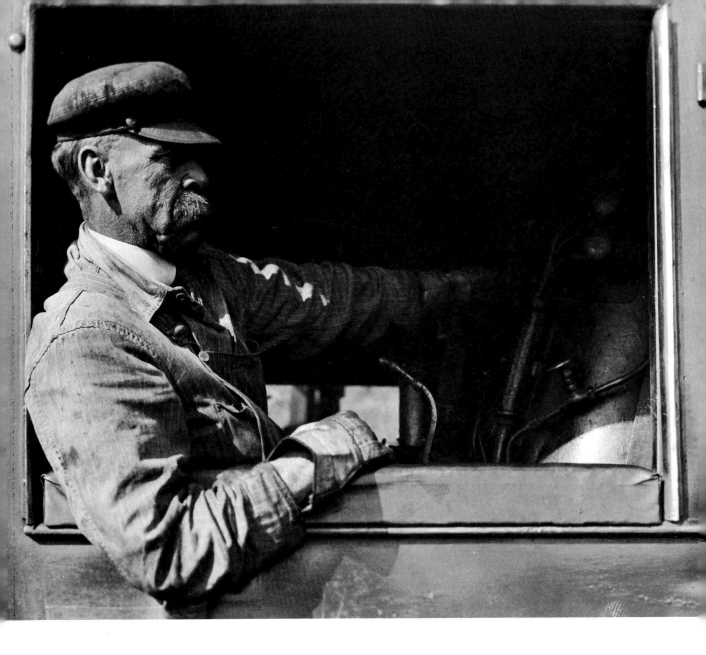

"Forty years in the cab, and I've never killed anything, human or animal." Such a record is the pride of this engineer. Opposite is a "cowboy of the yards," a brakeman who has galloped over America on the tops of many freight cars.

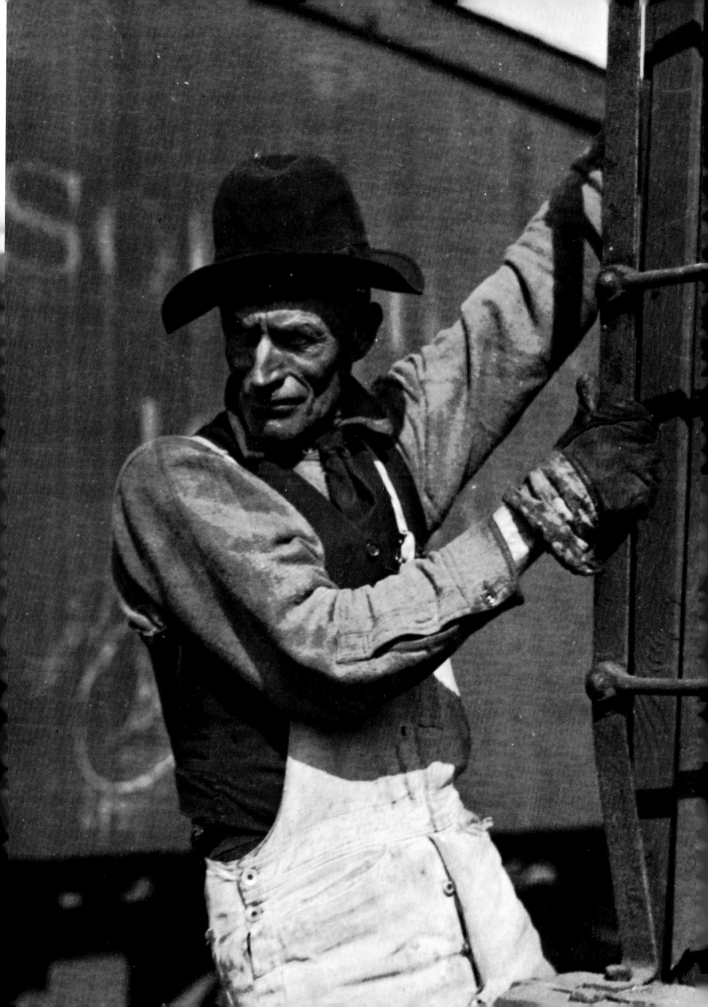

# MAKING

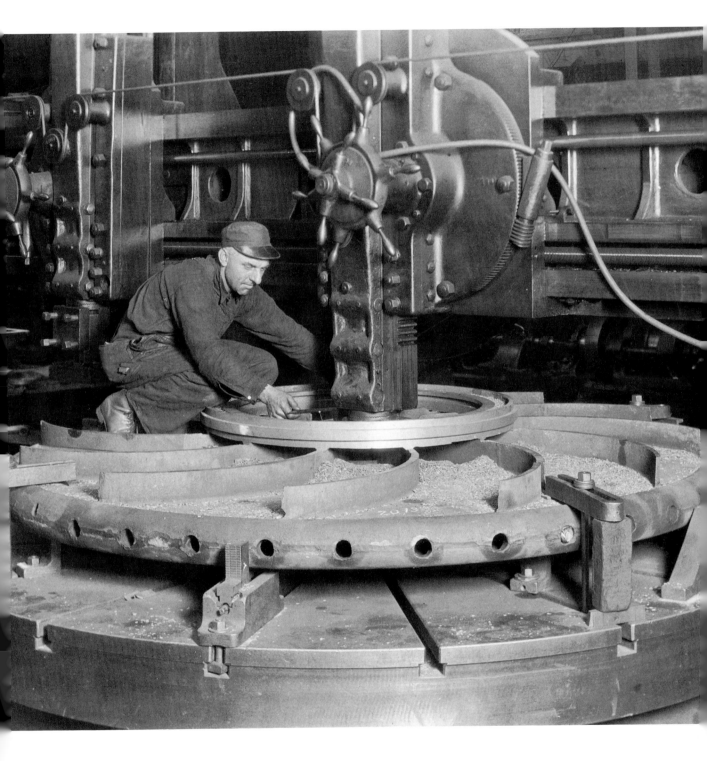

Grinding and adjusting the plates for a big turbine.

# MACHINES

Boring bolt holes with a power drill, on the chassis of a truck.

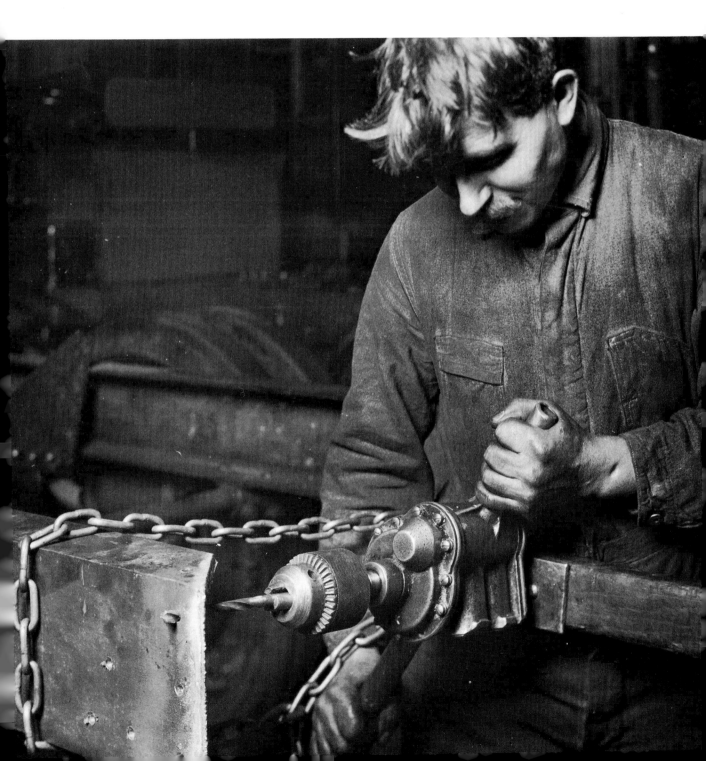

# TIRE

At the control wheel of an enormous calender, making automobile tires.

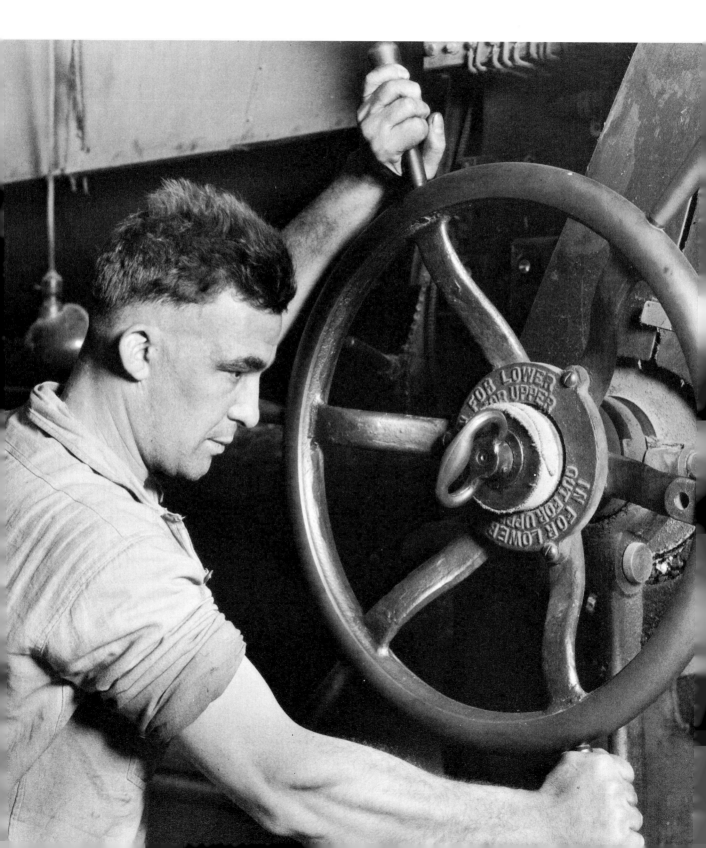

# MAKERS

The foreman checks up, while a skilled workman prepares the fabric for the tires.

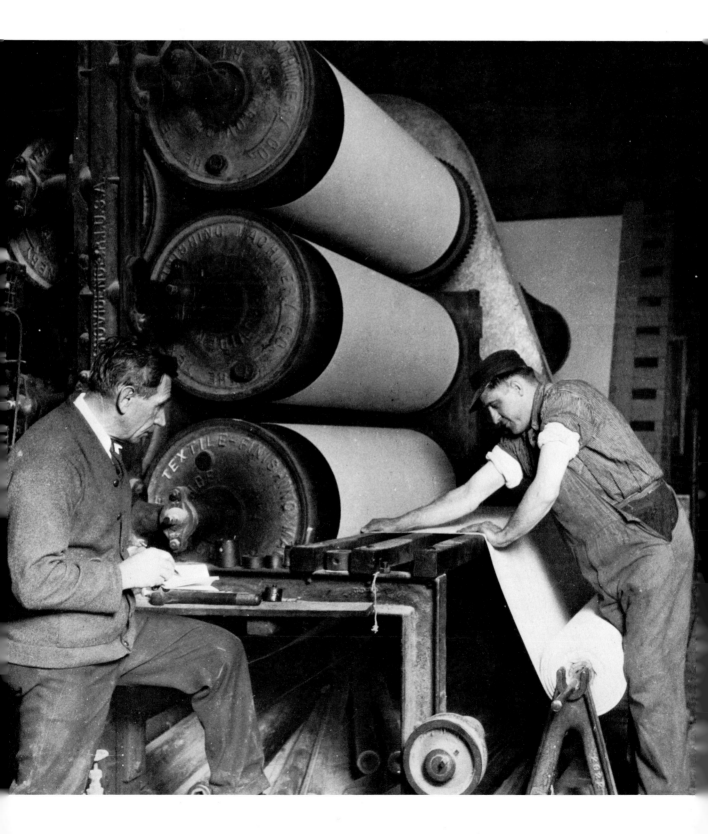

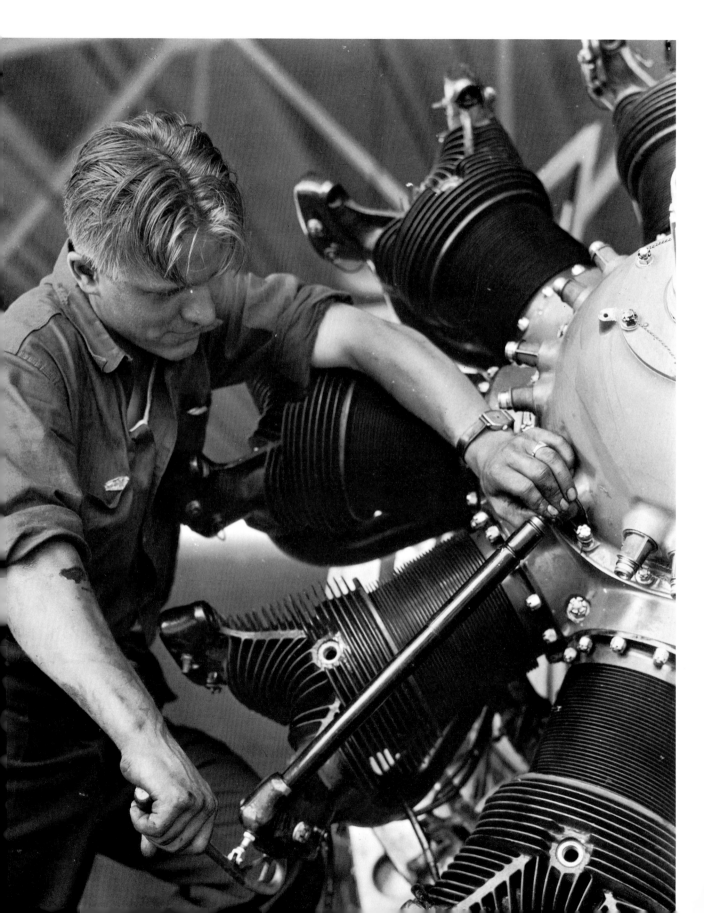

# MAKERS

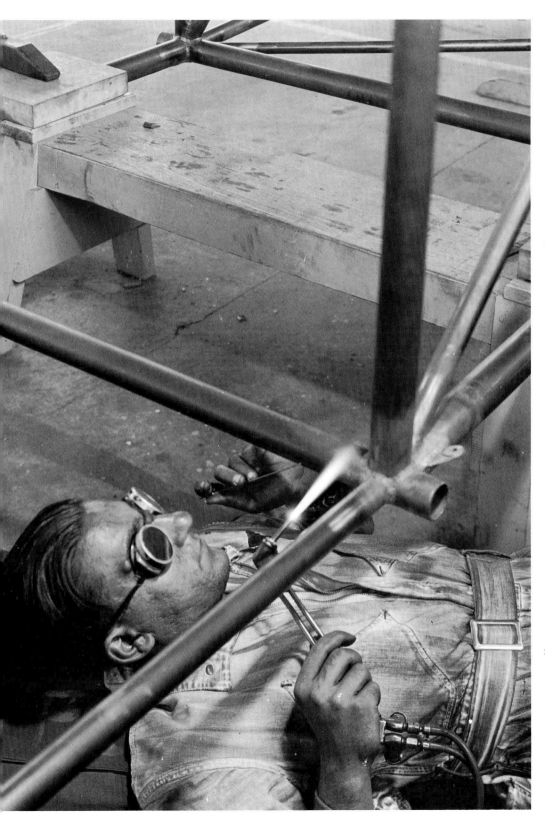

One skilled mechanic is at work on the radial motor of an airplane.

Another is welding the frame of an airplane; the slightest flaw would mean a smash-up.

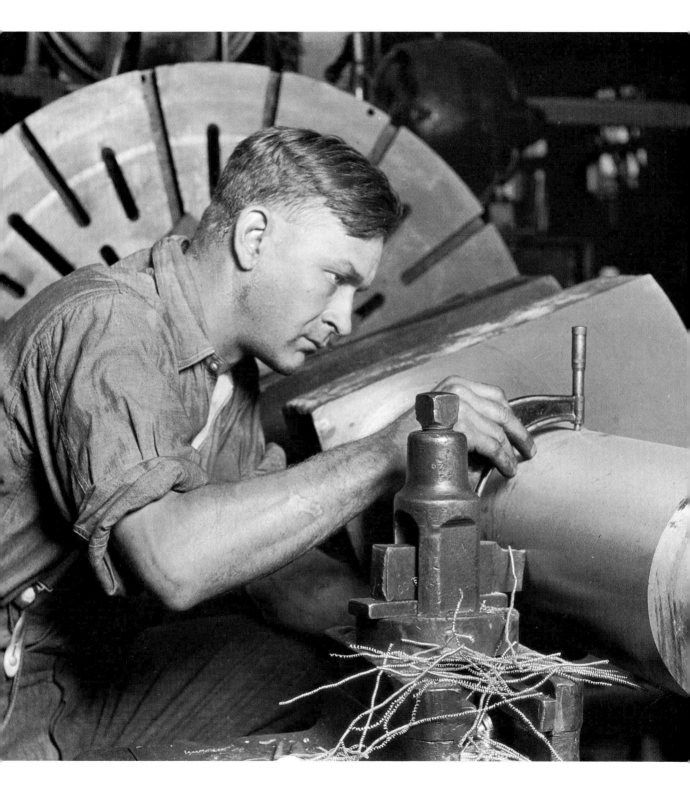

Man with micrometer, measuring the steel shaft of a large machine; he is trimming it down in a great lathe. His work must be accurate to the thousandth of an inch. Another skilled mechanic (opposite) beveling the gears for a small machine.

# SKILL

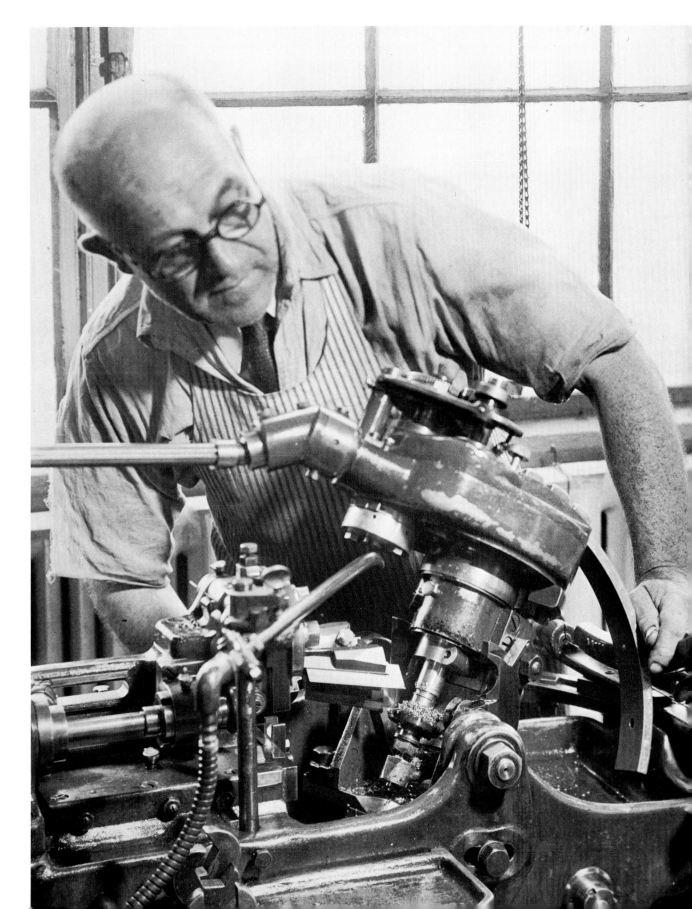

# COAL MINERS

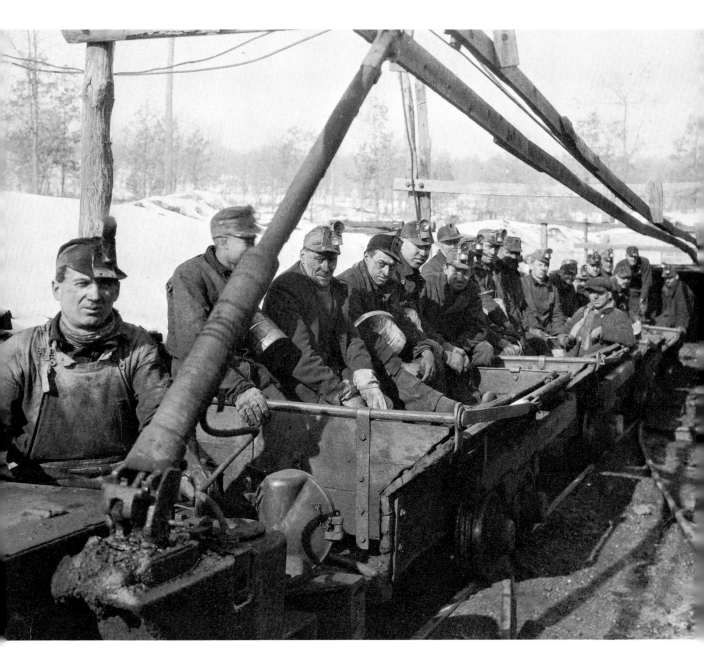

At the end of their shift, the miners come
up on a "man trip" in the empty cars.

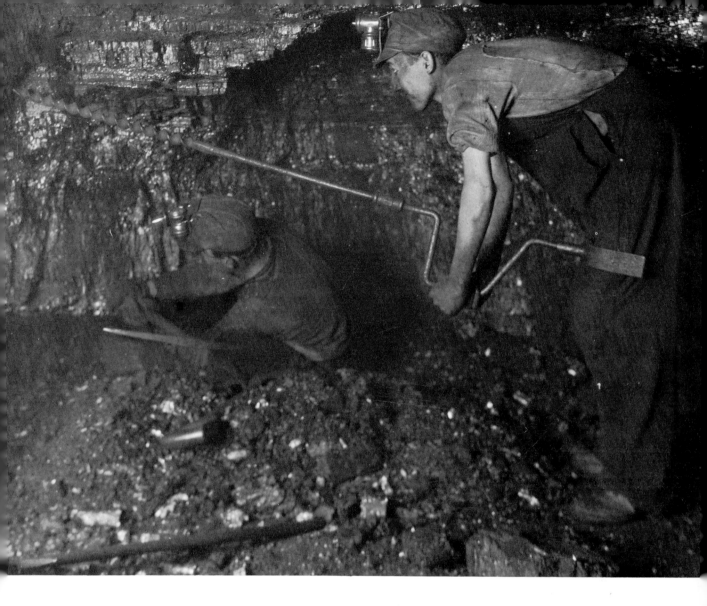

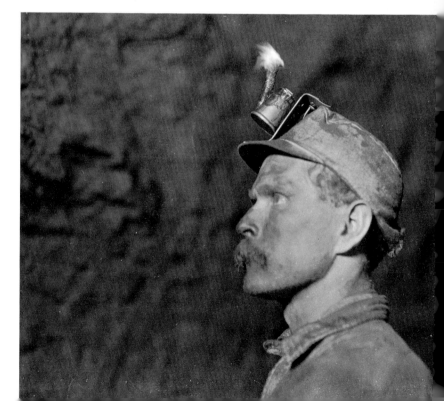

A pair of miners are drilling for a "shot," in a narrow seam of coal very deep down. Below them, a veteran miner with his lamp lit.

# In the Heart of a Turbine

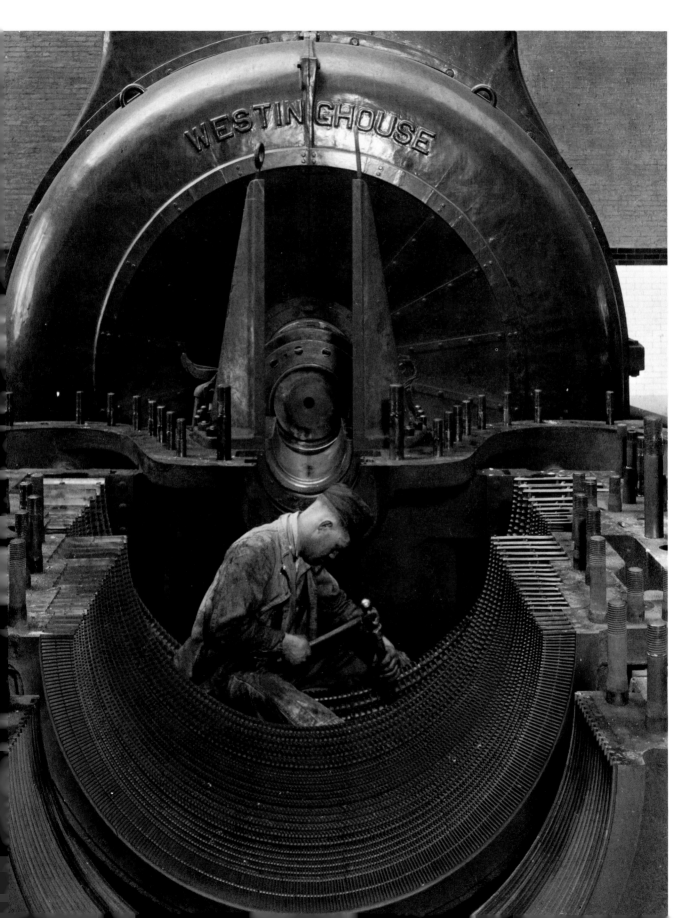

# Making a Great Transformer

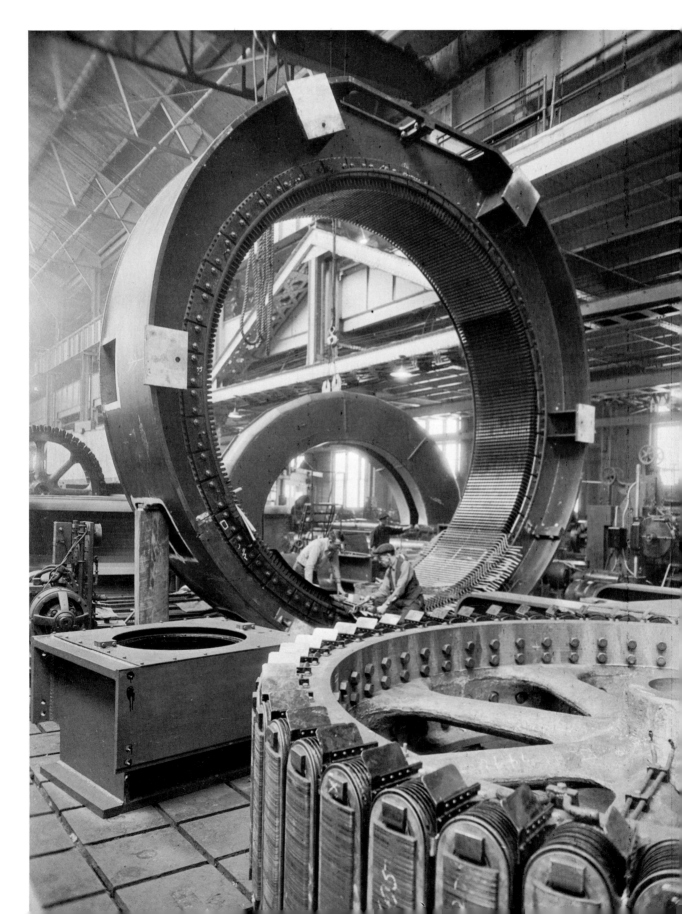

# SUPPLEMENT TO THE 1977 EDITION:
## Additional Hine Photographs of the
## Empire State Building Under Construction

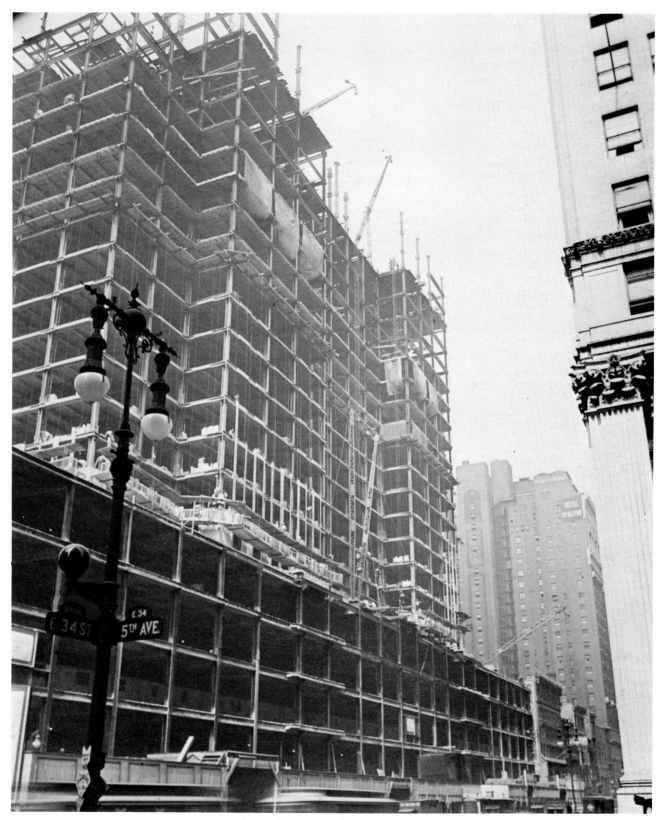

An early stage in the construction.

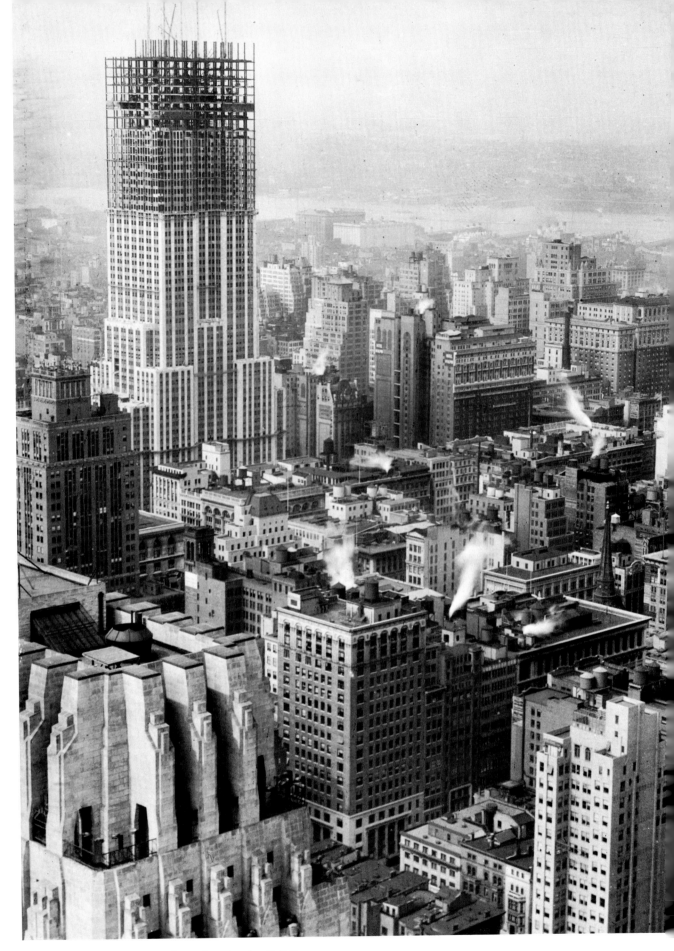

The rising structure as seen from the Chrysler Building.

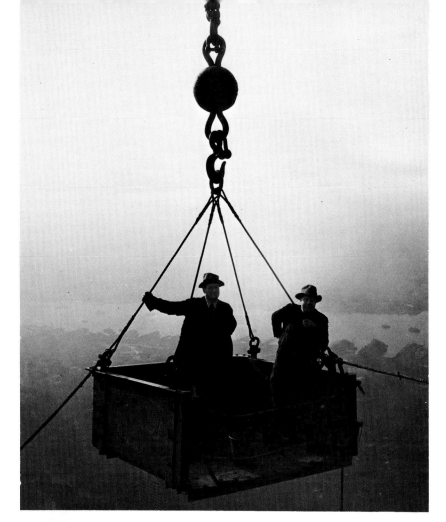

Two men in a derrick lift.

Placing the derrick high
up on the building.

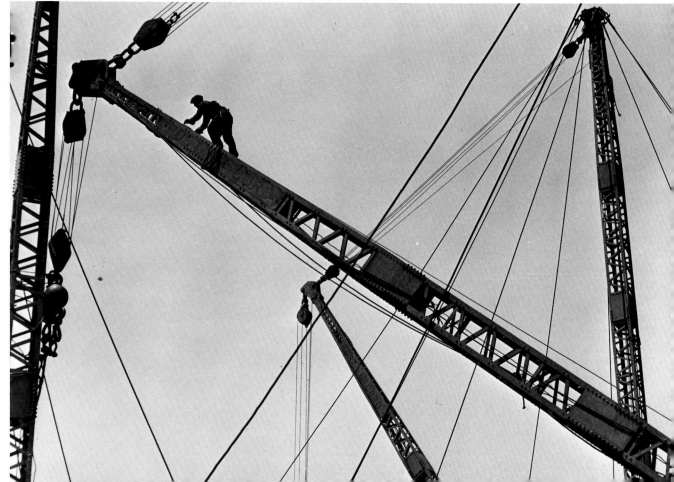

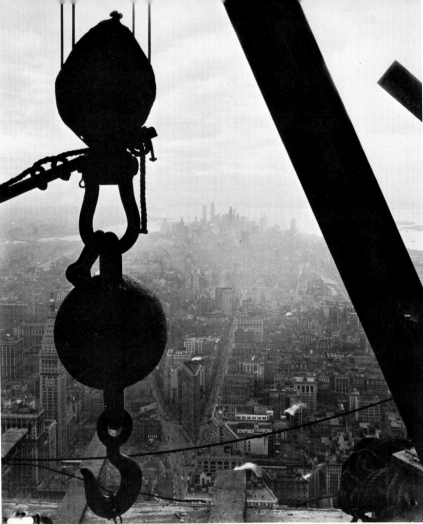

Looking out on lower Manhattan from the Empire State.

Laying a beam.

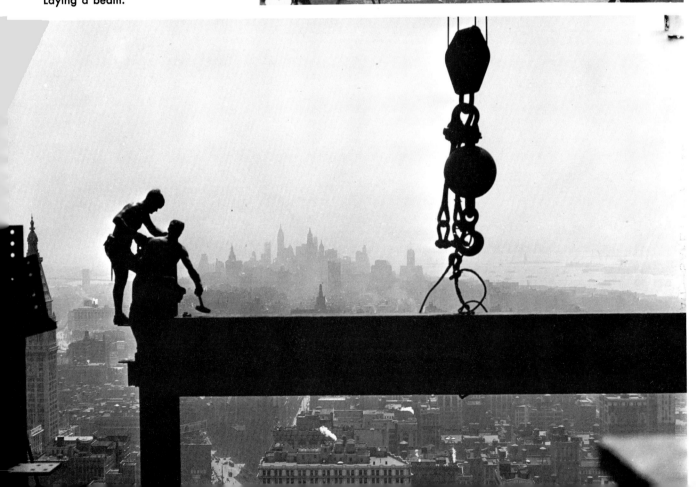

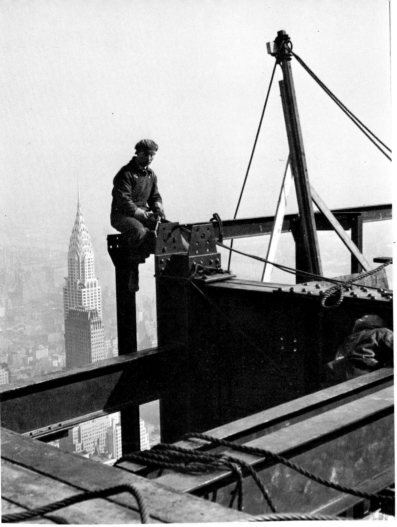

Workman on the Empire State with the Chrysler Building behind him.

On a cold day the riveters toast their sandwiches on the rivet forge.

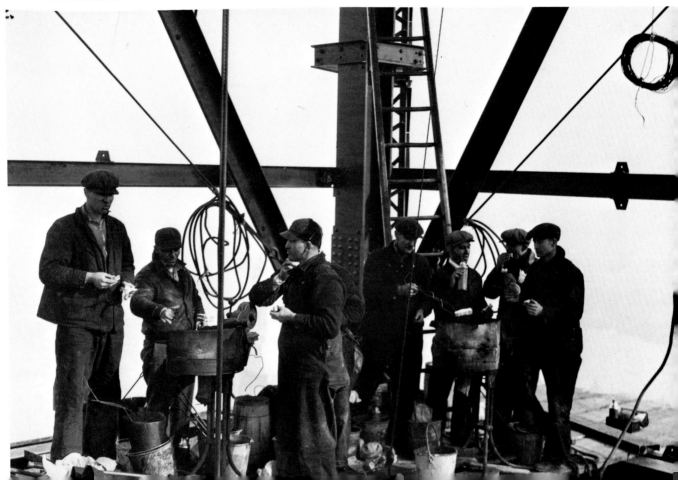

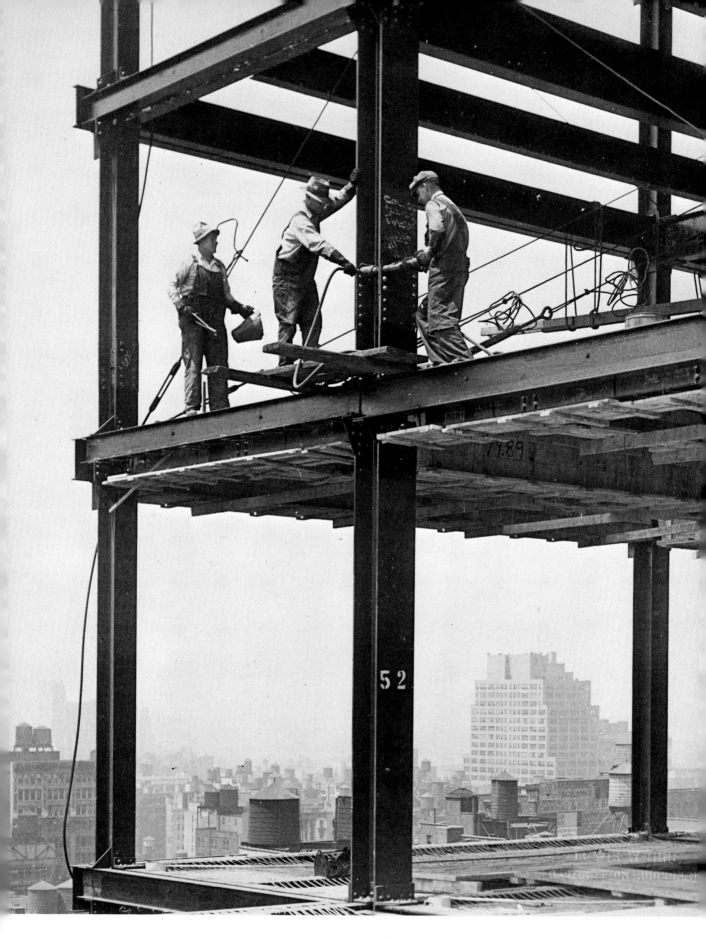

Rivet gang at work.

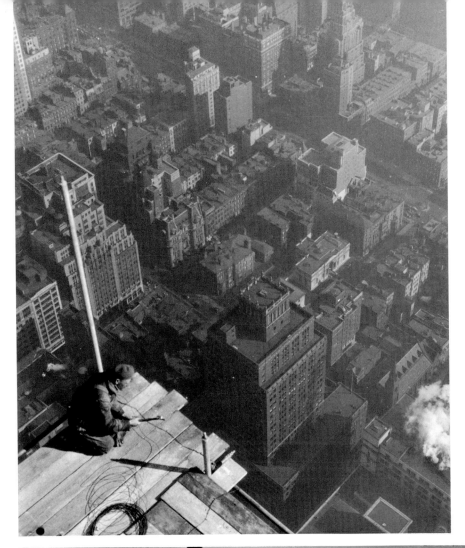

Gazing down upon a worker.

A glimpse of a workman driving one
of the last rivets on the mooring mast.

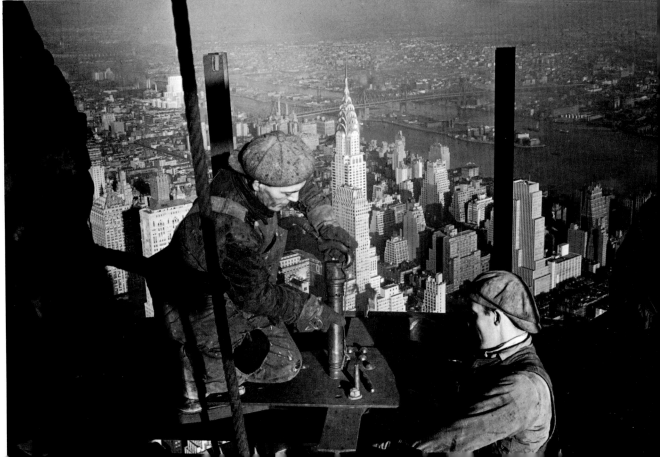

Bolting up a corner of the tower nearly
a hundred stories up.

Riveter at work.

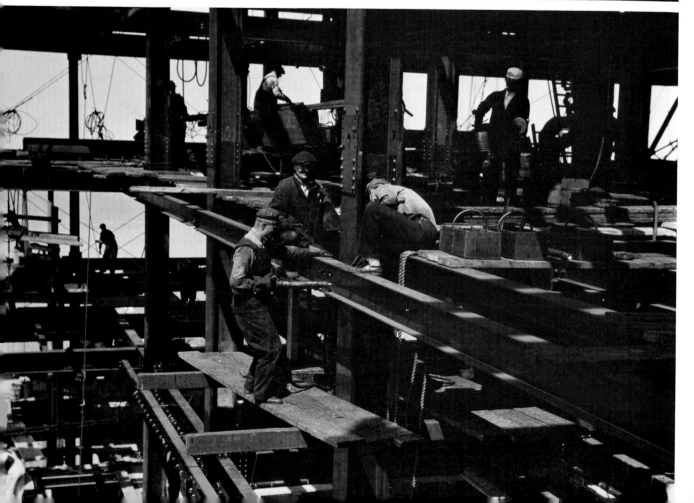

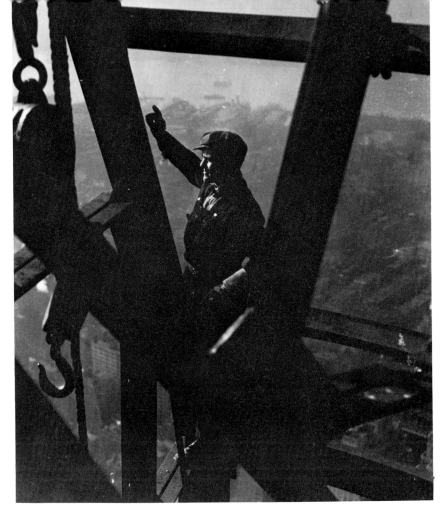

On the mooring mast, a quarter of a mile above the street.

Stonemasons at work.

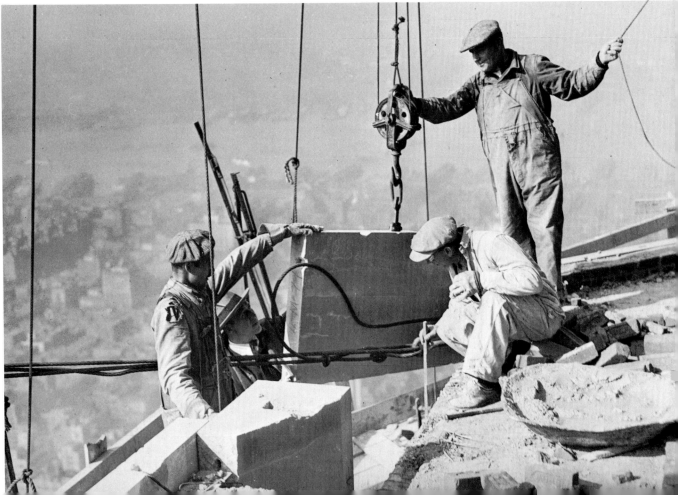

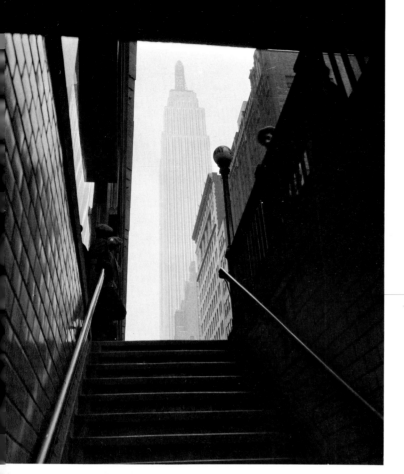

A glimpse of the nearly completed building from a subway entrance.

The "best bricklayer in New York" high up on the Empire State.

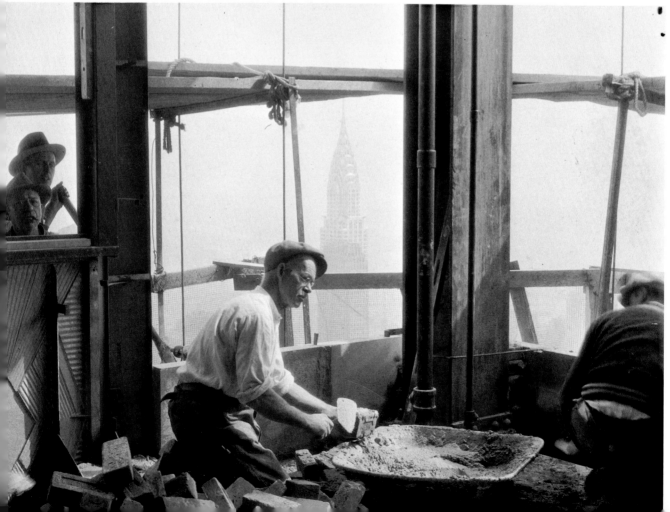

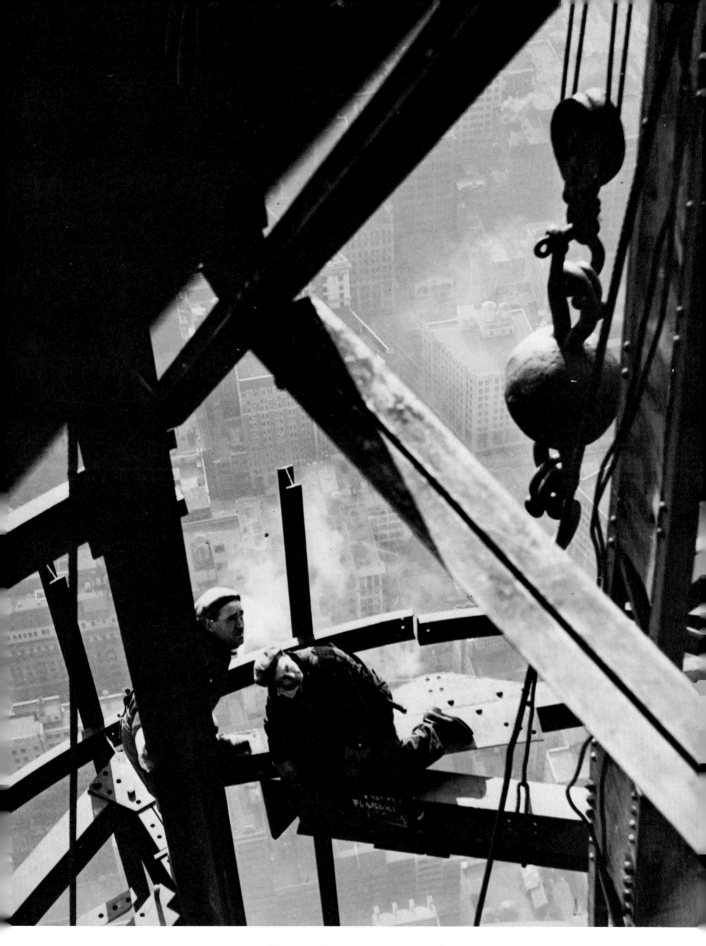

The mooring mast: men at work.